WITCHES & WICKED BODIES

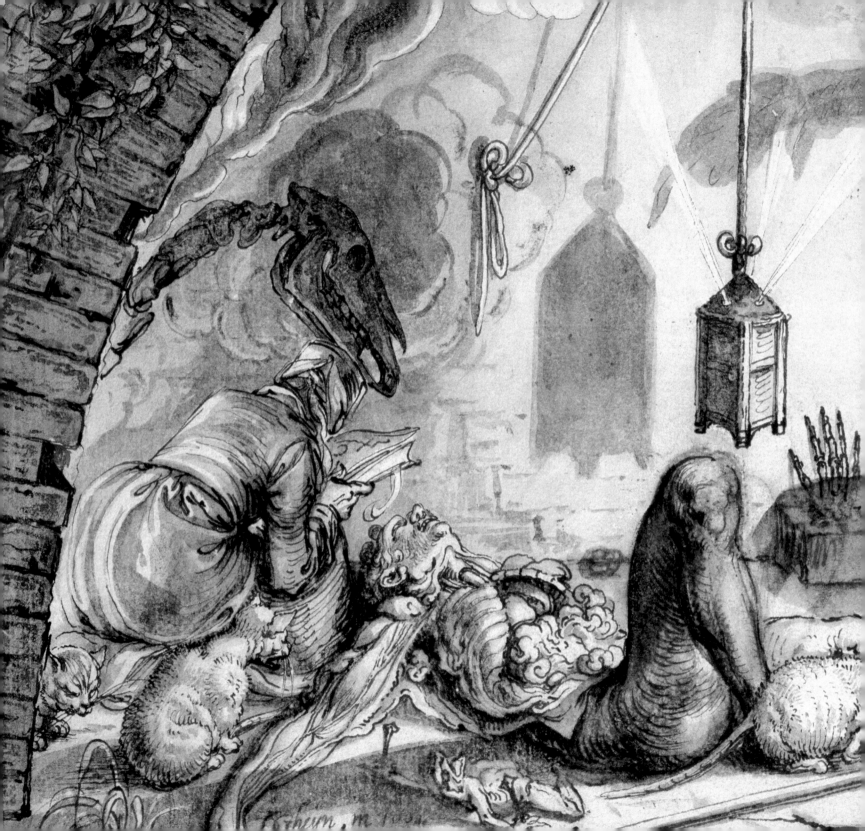

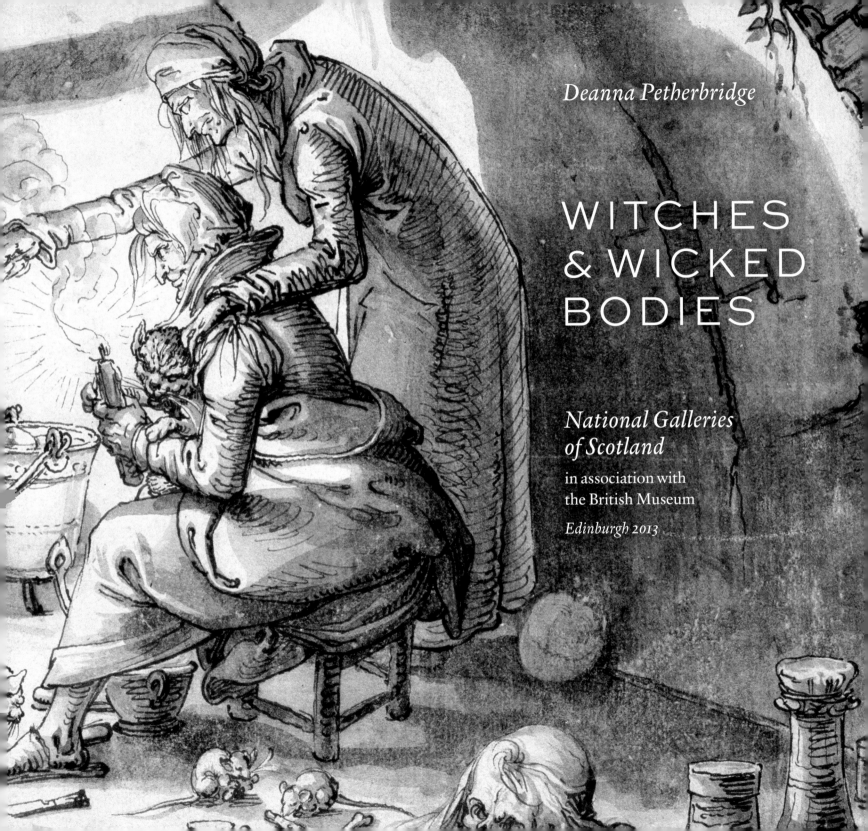

Deanna Petherbridge

WITCHES
& WICKED
BODIES

*National Galleries
of Scotland*

in association with
the British Museum

Edinburgh 2013

Published by the Trustees of the National Galleries of Scotland to accompany the exhibition, *Witches & Wicked Bodies*, held at the Scottish National Gallery of Modern Art, Edinburgh, from 27 July to 3 November 2013 in association with the British Museum.

ISBN 978 1 906270 55 1

Designed and typeset in Verdigris by Dalrymple
Printed in Spain on Perigord 150gsm by Grafos

Cover: detail from Agostino Veneziano (Agostino de' Musi) *The Witches' Rout* (The Carcass), c.1520, Scottish National Gallery, Edinburgh [cat.3]
Frontispiece: detail from Jacques de Gheyn II, *Witches in a Cellar*, 1604, Ashmolean Museum, Oxford [cat.31]

This exhibition has been made possible with the assistance of the Government Indemnity Scheme provided by Scottish Government.

The proceeds from the sale of this book go towards supporting the National Galleries of Scotland. For a complete list of current publications, please write to: NGS Publishing at the Scottish National Gallery of Modern Art, 75 Belford Road, Edinburgh EH4 3DR or visit our website: www.nationalgalleries.org

DIRECTORS' FOREWORD

Witches & Wicked Bodies is an exciting departure for the National Galleries of Scotland. This exhibition, which is presented by the Galleries in association with the British Museum, explores a highly original topic: artists' representations of witches from the Renaissance to the present day.

We are enormously grateful to Professor Deanna Petherbridge, both for approaching us with her initial idea for the exhibition and for all her hard work as its guest curator. Professor Petherbridge has been closely involved from the start: developing the exhibition concept, advising on the choice of works and facilitating loans, including a significant number of important works from other major British institutions. We have her to thank for the exhibition's broad chronological and geographical scope and its bold thematic structure. Visitors to *Witches & Wicked Bodies* are sure to appreciate the wide-ranging knowledge which underpins it.

Special acknowledgement must also go to the British Museum for agreeing to such a large number of loans. Other institutions were also generous: Birmingham Museums; the National Media Museum, Bradford; the National Library of Scotland; and the Royal Scottish Academy, Edinburgh; the University of Glasgow; Kirklees Museums and Galleries, Huddersfield; the National Gallery; the National Portrait Gallery; the Royal College of Art; Sprüth Magers; Tate; and the Victoria and Albert Museum, London; Manchester City Galleries; the Ashmolean Museum and Christ Church Picture Gallery, Oxford; the National Trust (Petworth House); Pratt Contemporary, Sevenoaks; and Southampton City Art Gallery.

Individuals from these and other institutions who have helped us to realise this project are many; they include: Maria Balshaw, Giulia Bartrum, Mercedes Cerón, Hugo Chapman, Tim Craven, Susan Foister, Julie Gardham, Andreas Gegner, Markéta Luskačová, Kathryn J. McKee, David McNeff, Rosie Micklewright, Jane Munro, Grant Scanlon, David Scrase, Ann Sumner, David Taylor, Jacqueline Thalmann, Helen Thornton, Helen Vincent, Jon Whiteley, Sandy Wood and Gordon Yeoman. Among the many scholars who have been very helpful to her, Deanna Petherbridge particularly wishes to thank Margaret Garlake, Helen Langdon, Lyndal Roper, Julian Treuherz and Juliet Wilson-Bareau.

Sincere thanks go to the many colleagues at the National Galleries of Scotland for their enthusiastic response to this exhibition, making it a truly cross-Galleries undertaking. Christopher Baker was the internal curator for much of the exhibition's development, passing the project on to Patricia Allerston, then Head of Education and now Deputy Director of the Scottish National Gallery, when he became Director of the Scottish National Portrait Gallery in August 2012. We thank both for their efforts. Elinor McMonagle, Curatorial Administrator at the Scottish National Gallery, justly deserves a special note of thanks for her consistent commitment and support. We have also valued the contributions of Christine Thompson and Sarah Worrall in our Publications team, as well as that of our volunteer, Loricha Honer, who helped with various aspects of the exhibition.

We save our final words of thanks for the Patrons of the National Galleries of Scotland who have provided generous financial support.

SIR JOHN LEIGHTON
Director-General, National Galleries of Scotland

MICHAEL CLARKE
Director, Scottish National Gallery

PREFACE

…What are these
So wither'd and so wild in their attire,
That look not like the inhabitants o' the earth,
And yet are on't? …

Banquo, in Shakespeare's *Macbeth*
Act i, Scene iii, lines 39–42

Witches & Wicked Bodies is an innovative survey of images of witches from the Renaissance to the early twenty-first century. The popular perception of the witch, as an ugly old woman in a pointed hat casting spells hunched over a cauldron or riding a broomstick while silhouetted against a night sky, is familiar. Our exhibition considers the rich and diverse visual culture which gave rise to this ubiquitous idea in Western Europe. It presents works of international importance, interspersed with images of national and local resonance. It consists largely of works on paper – just over sixty prints and drawings, and five photographs – by major European artists, including Albrecht Dürer, Lucas Cranach, Henry Fuseli, William Blake and Francisco de Goya. This selection of works on paper is complemented by a small but highly significant group of paintings, including one of the most famous of all witch pictures, Salvator Rosa's *Witches at their Incantations* from the National Gallery, London. The exhibition is brought up-to-date with the inclusion of some powerful works by major contemporary artists, including Paula Rego, Cindy Sherman, Ana Maria Pacheco and Kiki Smith.

For much of the period covered by this exhibition a witch was thought to be someone who practised magic, using supernatural means to effect good or evil. Fear of witches' ability to do harm provoked many responses over the centuries. *Witches & Wicked Bodies* does not explore the so-called European 'witch-hunts' of the sixteenth and seventeenth centuries – the strikingly widespread phenomenon whereby thousands of people were accused of witchcraft, with often devastating consequences – although these traumatic events form the backdrop to a large portion of the period covered. The principal subject of this exhibition is artists' fascination with witches; it centres on the fantastic images created of these compelling figures and not on the mundane reality of witches' lives.

This is the first significant British exhibition to focus exclusively on the subject of artists' representations of witches. It shows that from the late fifteenth century onwards, in keeping with the learned ideas circulating about witchcraft and its practitioners at the time, artists focused persistently on the most sensational aspects of witches' activities, such as their supposed attendance at sabbaths and their enthusiastic engagement in 'diabolic pacts', both of which were thought to have involved them in lascivious sexual practices.

The witches depicted are predominantly women, reflecting the strong association between women and witchcraft in the period covered by the exhibition. Just as the largest proportion of defendants accused of witchcraft in Western Europe during the sixteenth and seventeenth centuries were women, so the stereotype of the witch, which developed during the 1400s and informed intellectual ideas during the subsequent two centuries, was rooted in the basic assumption that witches were naturally female. In a sense, this exhibition addresses a very familiar topic – the ways in which women have been depicted within a male-dominated sphere of cultural activity – and society – over time: indeed the prototype of the witch, rediscovered during the Renaissance in the art and literature of classical antiquity, was also female.

Why there was such a strong association between women and witchcraft has never been completely explained, although many reasons have been given. High on the list, and affecting men of the world as well as cloistered clerics for much of the period, were inherited ideas about women being 'weaker vessels' than men, physically, intellectually and morally. This essential frailty was thought to have two effects: it made women more open to persuasion than men and it also made it more difficult for them to control their carnal passions. Both weaknesses, in intellectual thought of the period, made them susceptible to approaches from the Devil. The established roles of women within traditional society have also been thought to have made them vulnerable to accusations of witchcraft, the rationale being that activities such as cooking, healing and midwifery, which often required specialist knowledge of herbs and 'simples', also gave women an unusual degree of power over their fellow human beings. Conversely, early modern ideas about the essential vulnerability of women may have provoked concerns about the weakest members of the female sex, such as poor, old widows without social support or protection, using unnatural means to 'even up the odds'. The possibility that more women than men actually did practise magic, due to the various social reasons noted above, has also been suggested.

The exhibition and its accompanying catalogue are organised thematically, in six inter-related sections: *Hideous Hags & Seductive Sorceresses*; *Unnatural Acts of Flying*; *Witches' Sabbaths & Devilish Rituals*; *Unholy Trinities & the Weird Sisters of Macbeth*; *Magic Circles, Incantations & Raising the Dead*; and *The Persistence of Witches*. These themes highlight six

long-term visual concerns explored by artists. They range from the extreme ways in which witches have been depicted – as horrendously ugly old crones or dangerously beautiful sirens – to sinister views of witches' gatherings. Other themes trace the image of the witch riding through the night sky, encompass depictions of the weird sisters from The (justly famous) Scottish Play, and document a variety of other unsettling activities, including the practice of magic.

As well as allowing us to understand the ways in which visual ideas and vocabularies about witches have developed since the Renaissance, these thematic groupings also highlight the diverse range of artists' approaches to the subject. They show that while the ideas about witches represented in art have proved remarkably resilient over time, the ways in which images have been realised have varied greatly. Indeed, artists' representations of witches can be seen as being continually adapted, re-worked, appropriated and subverted according to the interests of each generation.

PATRICIA ALLERSTON
Deputy Director, Scottish National Gallery

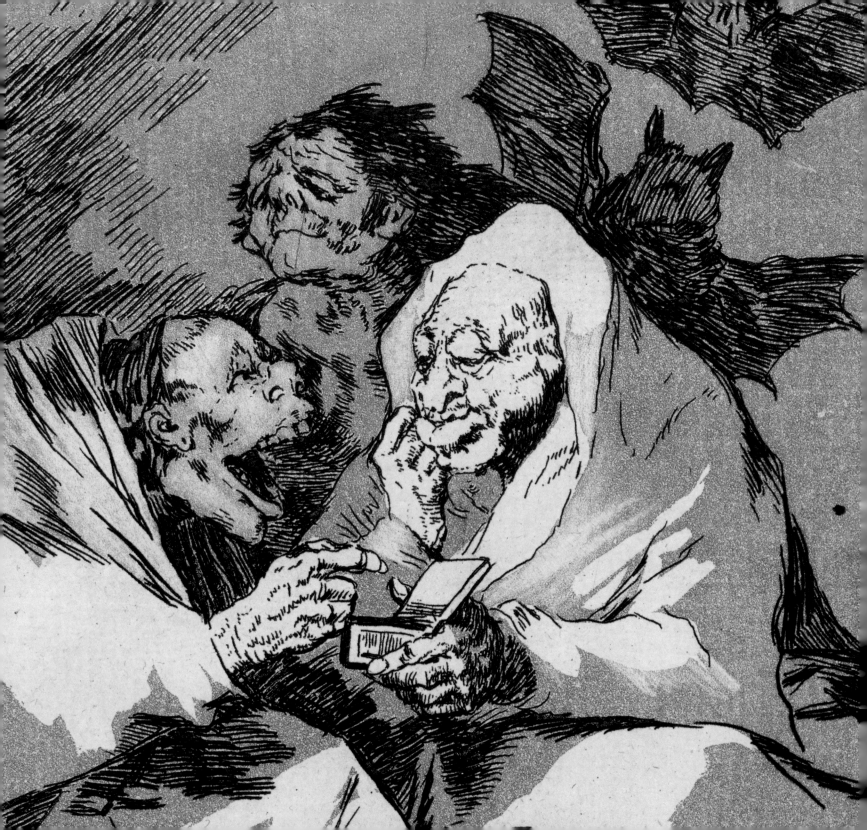

WITCHES & WICKED BODIES

< Detail from [11]

Witches carrying out evil deeds (*maleficia*) have traditionally been depicted in Western art, culture and religion as female figures. Such personifications range from the vicious bird-women harpies of Greek and Roman mythology, who tear at the tender bodies of infants in their cradles, to the Old Testament Witch of Endor, raising ghosts through incantations for purposes of prophecy. Winged harpies and sirens are pictured on vases or ancient sculptural reliefs, just as the beautiful sorceresses Circe and Medea are woven into the narratives of Hesiod, Homer and Ovid. These Greek and Latin epic poems have inspired artists, poets, playwrights and composers of opera throughout Europe for many centuries. In British culture they joined a rich seam of imagery derived from the Arthurian legends, Shakespeare, the Satanic figures of Milton and poetic translations from Goethe. The imagery of sorceresses readily crosses the boundaries of visual art forms but the links between visual representations of witches and literary, poetic and theatrical sources are particularly potent, as revealed in this exhibition.

Circe was just one of many classical enchantresses. She inhabited a remote island, threatened the safety of sea voyagers with storm-magic and turned stranded sailors into her slaves, in the degraded form of swine or four-legged beasts [14]. Medea, the wife of Jason, took to the skies in a dragon-chariot to gather the ingredients for her magic spells, either to assist the Argonauts, rejuvenate Jason's old father or destroy her rival for Jason's affections, killing her own children in revenge as the unnatural mother [15]. The witch Erichtho, the subject of an entire section in the unfinished historical epic, *The Civil War* (AD 61–5) by Lucan (Marcus Annaeus Lucanus AD 39–65), was pictured amongst tombs and graves, devouring cadavers or animating corpses for the purposes of divination; she belongs to an occult world but is not a denizen of Hades like Pluto. Witches have been associated with fire at all times, either carrying the flames of Venus to inspire desire in men, boiling their cauldrons over fires emitting foul fumes or flying to witches' sabbaths up chimneys. Fire was deemed the appropriate punishment for the heresy and crime of witchcraft in much of Europe, although in Britain witches were punished by water and ducked in ponds or hanged.

Women witches from the earliest times have been associated with but not identified by the elements of earth, air, fire and water, inspiring artists and writers to depict such

symbolic relationships in their settings of plays, poems or artworks. Witches were viewed as operating in the dangerous and contradictory realm of the in-between: as neither goddesses nor heroines as in classical myth, nor devilish creatures from hell, but as wicked mortals who were often seen as having signed a sexual pact with the Devil and used sorcery for evil ends. They inspire terror by existing in the interstices of traditional categories, and in the Christian world they deserve condemnation and punishment for subverting the natural/godly order of body and spirit, human and divine, good and evil, man/woman, human and animal. They particularly pose a threat to the patriarchal order by corrupting innocent men and under-mining the security of family life by attacks on fertility, pregnancy, and the nurturing of infants and livestock. In the case of old hags beyond the age of childbearing they are understood to be overwhelmed by envy of fertility and youthful beauty, wreaking acts of retribution on society by raising tempests at sea, conjuring lightning storms on land and destroying property and crops by fire.

The malefic nature of witches was propounded in the most potent and widely disseminated of European demonological texts: the deeply misogynist *Malleus Malificarum* (*Hammer of Witches*) of 1486/7, by the Dominican friars Jacob Sprenger and Heinrich Kramer. It explained why sorcerers were predominantly women, citing their inclination to superstition, deceit, defective intelligence, excessive vanity, lust and debauchery, and included material from the tenth-century *Canon Episcopi*, which sustained connections with the classical past: 'certain criminal women, converting back to Satan ... ride on certain wild animals with Diana, a goddess of the pagans, or with Herodias ... during the silence of the dead of night'.

Witchcraft is directly linked to the print revolution, not only in the spread of demonological texts (most of which, written by jurists, priests or clerics were in Latin and not translated into European languages for many centuries) but also in individual broadsheets with shocking or titillating images of witchcraft. Ulrich Molitor's *De lamiis et pythonicis mulieribus* (On Witches and Prophetesses, 1489), translated in an early French edition, contained a number of simple woodcuts including witches raising storms and embracing the Devil. The imagery is very far from the sophisticated world of Renaissance printmaking designed to equal the gravitas of painting, as in the powerful early sixteenth-century engraving *Lo Stregozzo* by the leading Italian printmaker Agostino Veneziano (*c*.1490–*c*.1540) [3]. The work owes much to

Albrecht Dürer [17]

the personification of Invidia (Envy) by Andrea Mantegna (c.1431–1506) as a shouting, skinny hag with wild streaming hair in the late fifteenth-century engraving *Battle of the Sea Gods*. Hanging phallic dugs with hardened nipples that offer no succour (and indeed harm rather than nurture) were to become the signifiers of witches' malevolence. 'Devil's marks', also described as teats, were supposedly hidden near the genital area of witches and accused witches were subject to public searches in witch trials. The ugliness of aged female bodies, depicted in Baroque emblem books such as Cesare Ripa's *Iconologia* (issued in many illustrated editions after 1593), relates to a long mediaeval tradition concerning the dangerous foulness of women after the cessation of the menses.

The great German artist Albrecht Dürer (1471–1528) had made copies after Mantegna's famous print and it is very possible that he was aware of the *Malleus Maleficarum* as his godfather, the successful publisher Anton Koberger, had issued editions in Nuremberg in the 1490s. As an artist deeply concerned with circulation and plagiarism issues (rightly accusing Veneziano of copying his prints) Dürer's two very small monogrammed witchcraft prints [1, 17] were widely distributed and highly influential. He and contemporaries such as Albrecht Altdorfer (c.1480–1538), the Swiss artist Niklaus Manuel Deutsch (c.1484–1530) and Dürer's pupil Hans Baldung Grien (1484/5–1545), helped to establish the appearance and iconography of witches in art, and their identification with issues of sexuality and bodily extremes: simultaneously horrific, mysterious and ridiculous.

Although many of Baldung's most titillating nude female witches were unique drawings on specially prepared coloured papers for private clients, he also produced paintings, such as *The Weather Witches*, 1523 (Städel Museum, Frankfurt) as well as the rich two-block chiaroscuro woodcut *The Witches' Sabbath*, 1510 that exists in various coloured versions [19]. Such luxurious prints were also produced by Lucas Cranach the Elder (1472–1553), a close personal friend of the religious reformer Martin Luther (1483–1546) in Wittenberg, although his didactic woodcuts for Luther's Bible, 1534 were far simpler. Cranach painted four versions of the *Allegory of Melancholy*, 1528 where the idleness or sloth (Latin, *accidia*) of the seated female figure allows the Devil to conjure flying witches in the sky [20]. The concept is related to the popular saying in many European languages that 'the Devil finds work for idle hands'.

Catholic Antwerp was an important and prosperous city in the early sixteenth century, and it was there, after his return from Italy, that Pieter Bruegel the Elder (*c.*1525–1569) designed prints for the publisher Hieronymus Cock (*c.*1517/18–1570), employing the apocalyptic and bizarre visual language of the earlier Flemish artist Hieronymus Bosch (*c.*1450–1516). The crowded activities in Bruegel's two images of the life of St James take place within a magical, shifting and illogical space that is simultaneously an interior and a wild exterior sky, with a view of an underworld below [18]. The southern and northern Netherlands (divided between Catholicism and Protestantism) were to have a profound influence on European representations of witches, not only through prints but also through the dissemination of paintings by artists who visited Rome in the seventeenth century. Jacques de Gheyn's (1565–1629) design for a print, *Preparation for the Witches' Sabbath*, *c.*1610 [30] was a key image, influencing the illustration of Judge Pierre de Lancre's (1553–1631) cruel rant against Basque (Labourd) witches, *On the Inconstancy of Witches* (1613) [35]. De Gheyn was closely associated with the poet and art historian Karel van Mander (1548–1606), who had made the distinction between art 'from the life' and 'out of the imagination', both combined in de Gheyn's predominantly graphic oeuvre.

Seventeenth-century demonological texts, listed in purient detail the presumed practices at witches' sabbaths. These events were presented as orgies where covens of witches and devilish monsters copulated promiscuously and worshipped the Devil, usually in the form of a goat, by kissing his backside. The anal kiss (a parodic inversion of the liturgical 'kiss of peace') is depicted in simple woodcut illustrations reproduced in the pages of the *Compendium Maleficarum* (1608), by the Ambrosian monk Francesco Maria Guazzo.

The growing complexity of witchcraft iconography found painterly excess in the works of the Antwerp artist Frans Francken II (1581–1642), who produced multiple copies of scenes set in witches' kitchens between 1606 and 1615 [68, 69]. In versions of the subject in the Kunsthistorische Museum, Vienna and the State Hermitage Museum, St Petersburg, a young bare-breasted figure is being undressed so that the curious placing of a cloak renders her visually 'disarmed', while another exposes her bare legs in a meretricious pose and groups of nude witches lie in drugged sleep on rough beds. The complex appurtenances of necromancy were carefully depicted in works by

Frans Francken II [68]

David Teniers the Younger (1610–1690), a follower of Francken, just as they were in the mid-seventeenth-century witch paintings of the Italian Salvator Rosa (1615–1673). Rosa, a proto-romantic poet and actor, and the friend of men of science, musicians, playwrights and philosophers with occult interests, relied on them to supply him with novel subject-matter for his paintings. He himself wrote a satire *La Strega* (*The Witch*), which was set to music, and produced a number of witch paintings, including a large *Scene of Witchcraft*, mid-1640s/60s (Galleria Corsini, Florence) with a dancing hag brandishing bones and an enormous skeletal monster, partially inspired by de Gheyn.

Artworks created in the historical period of the great witch trials exhibit an intensity and drama irrespective of whether their authors believed in witchcraft or not. Debates about witchcraft were often sceptical, even at the most intense moments of persecution. The Lutheran physician Johannes Weyer (1515–1588) spoke out against the burning of witches and Alonso de Salazar Frías (c.1564–1635), a Spanish inquisitor, repudiated the Basque witchcraft trials of Logroño in official reports in 1611. The Englishman Reginald Scot (c.1538–1599) is often applauded for the 'enlightened' scepticism of *The Discoverie of Witchcraft* (1584), a book that much angered King James VI of Scotland (King James I of England and Ireland 1603), author of *Daemonologie* (1597), who understood himself to be a victim of witchcraft. The king was closely involved in the infamous North Berwick witch trials of 1590. Scot's argument is expressed in misogynist language as virulent as that of the *Malleus*:

Witches are … old, lame, bleare-eied, pale, ffowle and full of wrinkles; poore, sullen, superstitious, and papists;… They are leane and deformed, shewing melancholie in their faces, to the horror of all that see them. They are doting, scolds, mad, divelish …

French artists and writers maintained a much lighter mode of scepticism, as in the playful fantasy etchings of Claude Gillot (1673–1722) [39, 40] or Laurent Bordelon's *A History of the Ridiculous Extravagancies of Monsieur Oufle…*(translated into English, 1711).

By the end of the seventeenth century many countries had repealed their laws against witchcraft, and in Enlightenment Europe witchcraft was often seen as the backward-looking superstition of an ignorant peasantry, a subject of antiquarian interest or satire.

This was the position in Francisco de Goya's (1746–1828) Spain when he painted witches in the 1790s and later created wild intense scenes of witchcraft on the walls of his villa outside Madrid, the *Quinta del Sordo* in the 1820s (*The Black Paintings*, now in the Museo del Prado, Madrid). Goya's sexually-indeterminate and hideous *brujas* (witches) that dominate the print series of *Los Caprichos*, 1799 act as symbolic embodiments of evil: satirical but potent expressions of his outrage against the clergy, political repression and all manner of social evils and 'follies'.

By contrast the Swiss-born Henry Fuseli (Johann Heinrich Füssli 1741–1825), Goya's almost exact contemporary, employed witch imagery in pursuit of romantic excess and 'Gothic' horror. His mannered and sensationalist imagery, most notably *The Nightmare* (Detroit Institute of Arts), 1781, often resulted in parody, and caricaturists of the day gleefully used his imagery for political satires. This was the time of the establishment of the Royal Academy of Arts, London, with artists turning to the great traditions of Jacobean theatre and English poetry to produce history paintings in the construction of a native British School. Like his contemporaries, Fuseli contributed grand paintings to the annual Academy exhibitions and the Shakespeare Gallery, opened in London in 1789 by the print publishers John Boydell and his nephew, as well as producing a body of work for his own short-lived Milton Gallery. His influence was considerable, extending via his friend William Blake (1757–1827) and the much younger Theodor von Holst (1810–1844), to Dante Gabriel Rossetti (1828–1882).

The Pre-Raphaelites were as taken with images of the femme fatale as they were with literary revivals of evil sorceresses. Rossetti (in many ways a modern Salvator Rosa in the manner in which he straddled art forms and constructed an outrageous and theatrical persona) produced poetry, drawings and paintings of *Lilith*, the 'Queen of the demons', while William Morris's long poem on the *Life and Death of Jason* (1867) inspired Frederick Sandys's intense painting of *Medea*. The revival of interest in Rosicrucianism in England, France and Germany in the mid-nineteenth century was followed by a virtual passion for the occult by the end of the century. Séances, mediums, table-tapping, Astral travel (indulged in by members of the Theosophical Society) and membership of secret societies such as the Hermetic Order of the Gold Dawn, engaged intellectuals

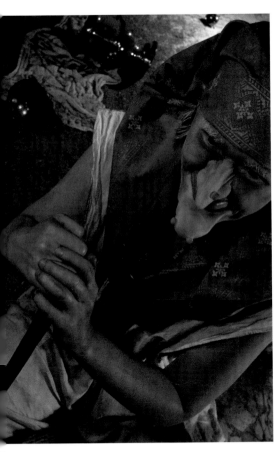

Cindy Sherman [83]

and scientists from W.B.Yeats (1865–1939) to Carl Jung (1875–1961). This interest in magic was even taken up within pictorial photography. In France, *Là-Bas* (*The Damned*) (1891) by the civil servant and art critic Joris-Karl Huysmans, contained scenes of Satanism in bourgeois society that would inspire the visual artists of the Decadent and Symbolist movements. The Spanish painter Ignacio Zuloaga y Zabaleta (1870–1945) painted popular paintings of witches' covens, while the Belgian printmaker and illustrator Felicién Rops (1833–1898), illustrator of the frontispiece Baudelaire's *Les Épaves* (Scraps) (1866), created horrific images of polluting female figures, such as the print *Mors Syphilitca*, *c.*1892. Her terrible potency was taken up by the twentieth-century German Expressionist artist Otto Dix (1891–1969) who so often depicted women as wizened or bestial prostitutes in his social satires. Such images lingered within the dream images of Surrealism.

In her influential *The Witch-Cult in Western Europe* (1921) the archaeologist and folklorist Margaret Murray proposed that witches' covens were survivals of Neolithic pagan worship and the horned Devil of witchcraft confessions and art was the hieratic mark of a cult priesthood catering to this irrepressible matriarchy. Her notion of benign witchcraft (Wicca is now divided into many separatist cults) offered narratives of female empowerment and a 'return to nature'. The figure of the witch remains important to scholars of women's history today, according to the literary historian Diane Purkiss, because 'it mirrors the many images and self-images of feminism itself'. (*The Witch in History*, 1996)

Women artists who engage with witch imagery run the risk of being accused of 'pandering to stereotypes', yet the images of Kiki Smith (b.1954) and Cindy Sherman (b.1954) are extremely potent and thought-provoking. Paula Rego (b.1935) has shown no qualms in appropriating the witch figure for political satire in the spirit of Goya, in campaigns towards legalising abortion or banning female mutilation, and Ana Maria Pacheco (b.1943) employs time-honoured artistic traditions of animating public symbols with personal inflections of the uncanny. Sherman's *Untitled No.151* [83] is cropped diagonally so that the enlarged face of the hideous witch in her headscarf is close to the viewer, as if she is rising from the ground. As participating spectators, we imaginatively fill in the missing broomstick that enables her to fly away.

DEANNA PETHERBRIDGE

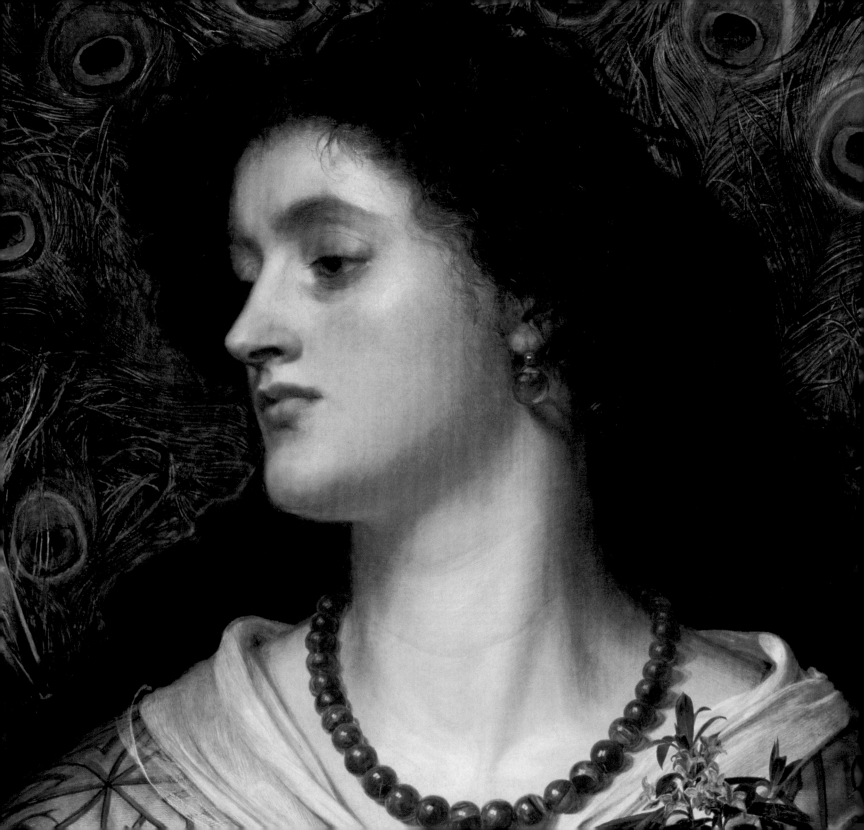

HIDEOUS HAGS &
SEDUCTIVE SORCERESSES

< Detail from [16]

Over the centuries witches have been either depicted as hideous and emaciated old crones with long dugs and wild hair intertwined with writhing snakes, or as beautiful seductresses who 'bewitch' unwary men with their dangerous charms.

Witch hags are identified with the emblematic image of Invidia (Envy) who stalks the earth eating her heart out with jealousy of the fortunate and vents her malevolence by causing storms, fires and natural disasters and by raising tempests at sea. Witches are so envious of fertile and sexually attractive young mothers that they sour their milk, cause miscarriages, substitute changelings in the cradle and even cannibalise babies or use their body parts for making evil potions. They render men impotent and kill livestock.

The myth of the beautiful sorceress who lures, seduces and casts spells upon innocent men was prevalent in the classical world and the Renaissance. Figures such as Circe, who enchanted Ulysses and turned his men into beasts, or the sorceresses Alcina and Armida, have inspired operas, poems, theatrical performances and artworks over the centuries. Like the cabbalistic Lilith whose 'dangerous' hair entwines men, and the biblical Eve who promotes primal sin, such evil women, the familiars of serpents, utilise their sexuality to ensnare men for malevolent purposes.

The image of the beautiful sorceress as harlot is also associated with the lives and tribulations of Christian saints, specifically Saint Anthony Abbot. His encounters with demons and monsters, including the very Devil himself in disguise as a beautiful young temptress, form an important source for witchcraft imagery.

The dangerous but infinitely alluring femme fatale has remained a potent figure in European art well after witchcraft ceased to be regarded as an actual threat to society and religion and assumed its present metaphorical status. It was developed by the Romantic poets and became a potent theme for artists in the nineteenth century, particularly the Pre-Raphaelites.

In prints, drawings and paintings, old and young witches are depicted stirring up storms in a cauldron or boiling up the ingredients of magic spells surrounded by clouds of filthy smoke. They themselves are the source of foul emissions in many satirical images.

1 ALBRECHT DÜRER (1471–1528)

The Four Witches, 1497

Engraving, 19.1 × 13.3 cm
Scottish National Gallery, Edinburgh

This mysterious engraving has always been understood to be about witches, although the Devil emerging from the flames of hell to the left of the standing figures is difficult to notice. A skull and leg bone on the ground add a sinister dimension to a print that seems to relate to the three ages of women or the three Graces. There have been innumerable interpretations of the work, including a suggestion that the 'O.G.H.' written on the dated sphere above their heads stands for *'O Gott hüte'* (Oh God save us) [from witches]. This extremely famous and widely distributed print established a late Renaissance precedent for depicting witches as nude young women, whose very beauty and desirability can be a threat to men, especially when they congregate as a coven. Dürer's other influential occult print, *Witch Riding Backwards on a Goat* [17], depicts the contrasting image of a hideous old crone riding a goat and holding a broomstick. Dürer's pupil Hans Baldung Grien was to expand Dürer's limited excursions into witchcraft into a developed practice exploring a combination of horror and titillation.

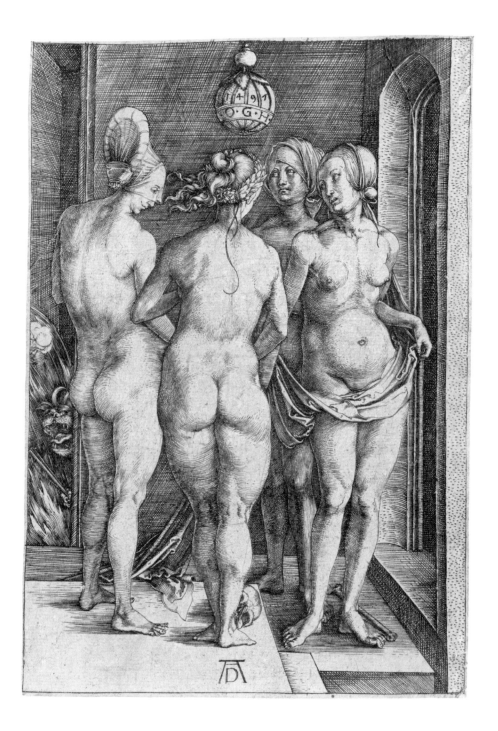

2 HANS MIELICH (1516–1573)

Witches' Gathering, 1535
Pen and black ink heightened with white
body colour, on dark brown prepared paper,
21.7 × 15.5 cm
Scottish National Gallery, Edinburgh

Mielich, a leading painter in Munich
during the third quarter of the sixteenth
century, is thought to have studied with
Albrecht Altdorfer, author of a fine
drawing on a red-brown ground, *Departure
for the Sabbath*, 1506, in the Musée du
Louvre, Paris. The pen outlines and
abraded white highlights of Mielich's
work have sunk into the dark brown
prepared paper, but the three figures in
the foreground of the ghostly woodland
setting are undoubtedly rude and sexy
witches. The standing figure on the left
brandishes a smoking vase in one hand and
a very large phallic sausage in the other;
the nude on the ground with flowing hair
is preparing some ghoulish platter; and
the third of the group has put her hand
under her skirt in a gesture of deliberate
obscenity that recalls the explicit coloured
drawings of witches by Baldung. In the
middle distance a wild demonic witch with
a huge curved wand appears to be beating
a victim or cadaver to pieces. This work
is a typical German sixteenth-century
amalgam of nakedness, sly symbols of
sexuality and anality, composed with the
greatest fineness of execution. The slightly
squat bodily proportions relate to those in
Mielich's coloured altarpieces.

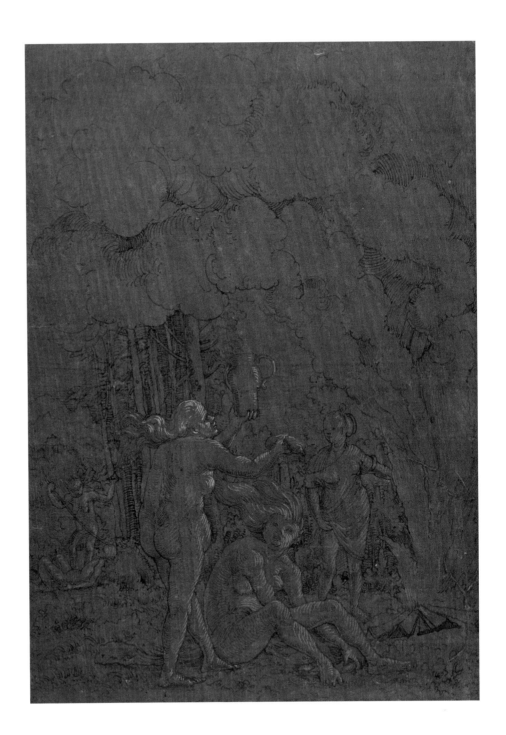

3 AGOSTINO VENEZIANO
(AGOSTINO DE' MUSI) (c.1490–c.1540)
The Witches' Rout (The Carcass), c.1520
Engraving, 30.7 × 64.8 cm
Scottish National Gallery, Edinburgh

It is not certain either who designed or engraved this very well-known and intense early sixteenth-century print, often entitled *Lo Stregozzo* (*The Witch's Procession*). The conception has been variously attributed to Raphael (1483–1520) or his pupil Giulio Romano (*c.*1499–1546), and its execution to either the great Renaissance engraver Marcantonio Raimondi (*c.*1480–*c.*1534) or his pupil Agostino Veneziano. The attribution of the print to Veneziano is now widely accepted; the second state of the print bears his monogram. However, there is no doubt that the naked hag being pulled along in the skeletal carcass of some extraordinary monster is a malevolent witch. Her hair streams backwards in wild disarray and her naked dugs hang down. She holds a steaming vase in one muscular arm and reaches out for the infants resting amongst the ribs to devour them. She is surrounded by goats and demons and the setting appears to be marshy wetlands. The image stems from the depictions on ancient bacchic sarcophagi, where typically Bacchus in a chariot or Silenus on a donkey is accompanied by a lively procession of music-making, dancing fauns and bacchantes. The subject possibly relates to a contemporary text about witchcraft called *Strix, or the Deceptions of Demons* (1523), by Gianfrancesco Pico della Mirandola.

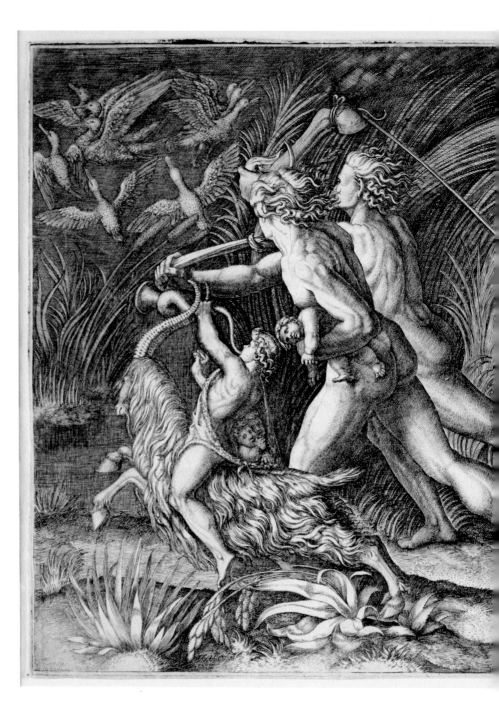

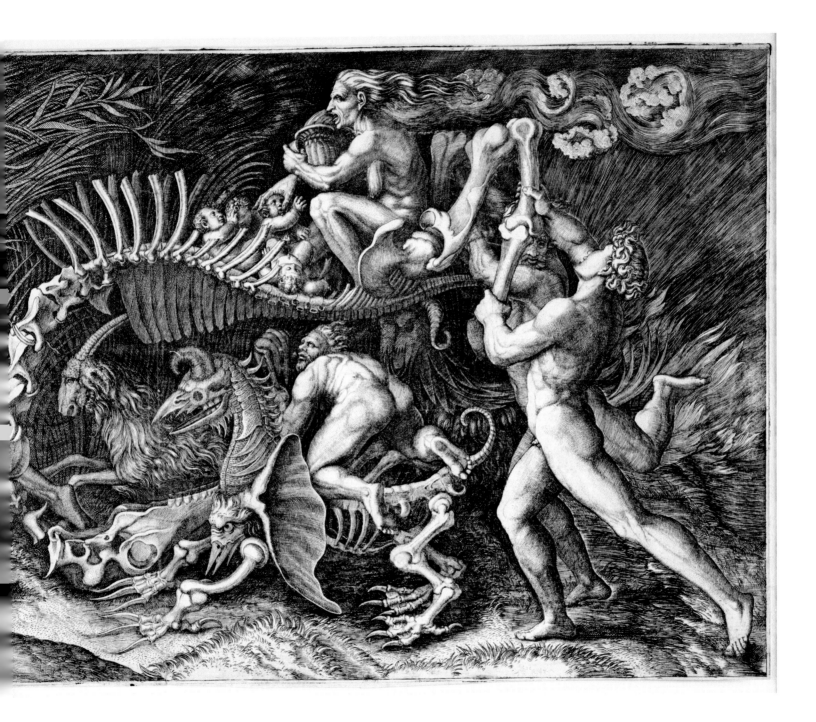

Invidia (*Envy*), 1596–7

Engraving, 22.7 × 16.5 cm
British Museum, London

The hideous old hag has serpents for hair,
and is eating her own heart out of envy
of the good fortune of others. The figures
next to the kiln are locked in a dispute
that she has cruelly instigated, just like
the fires, destruction and havoc left in her
path. This powerful work was engraved by
de Gheyn's pupil Dolendo from a drawing
and belongs to a series of prints of *Vices
and Virtues*, a popular subject for the pious
at the time. The Latin verses were written
by Hugo Grotius, a well-known judge,
poet, playwright and a friend of the artist.
Envy's repulsive body relates closely to the
verses that appeared in versions of Andrea
Alciati's illustrated *Emblem Book* (1531):

> *A squalid and ugly woman*
> *who feeds on viper flesh*
> *and eats her own heart*
> *whose livid eyes always ache*
> *who is thin, pale and dry*

Envy was perceived as one of the
main motivations of the malevolence
of witches. They were thought to be
especially envious of fertility, and caused
miscarriages, soured women's milk,
substituted changelings in the cradle,
devoured babies or used the fat of
unbaptized infants for their magic flying
potions.

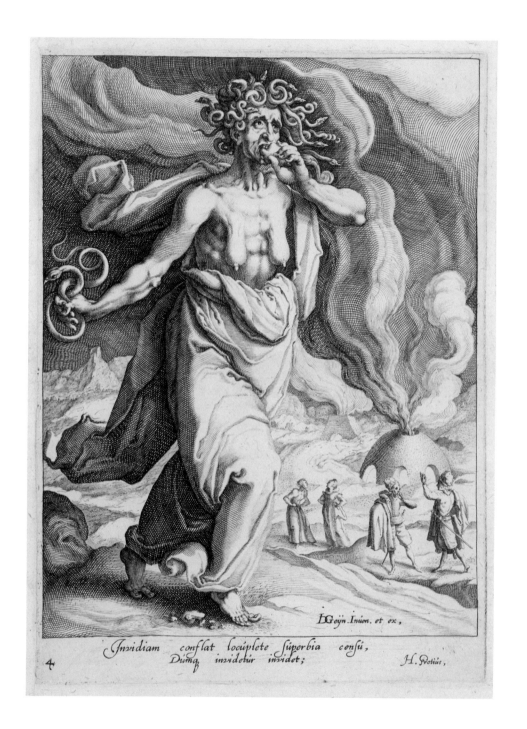

5 MELCHIOR KÜSEL (1626–c.1683)

Allegory of Discord, 1670

Etching, 23.3 × 22.5 cm
Ashmolean Museum, Oxford

As a variant of Envy, Discord is a bony old hag in tatters with snake-infested hair and long dugs with venomous nipples, stalking the earth to create havoc. She stokes the fires of discord with her bellows, and not only has she instigated furious arguments and fisticuffs on earth, where even the dogs are fighting, she has created disharmony amongst the Olympian gods. A semi-naked witch, floating in the dark fumes in the sky, orchestrates the dispute. The arrangement of the gods seated in a semicircle in the sky owes much to Raphael's *Mount Parnassus*, 1510/11 (Vatican Palace). The classical author Ovid in his *Metamorphoses* described how Envy tramples flowering meadows and pollutes cities with her tainted breath, and turns people to stone by infusing them with her pitch-black venom. Küsel was an engraver based in Augsburg, Vienna and Munich; he published typical witch subjects such as *Tempests at Sea*, 1640s. Ben Jonson had featured Discord in his Twelfth Night masque, 1646 as, 'a malicious Fury' who appears in a storm and 'by the invocation of malignant spirits … put most of the world into discord'.

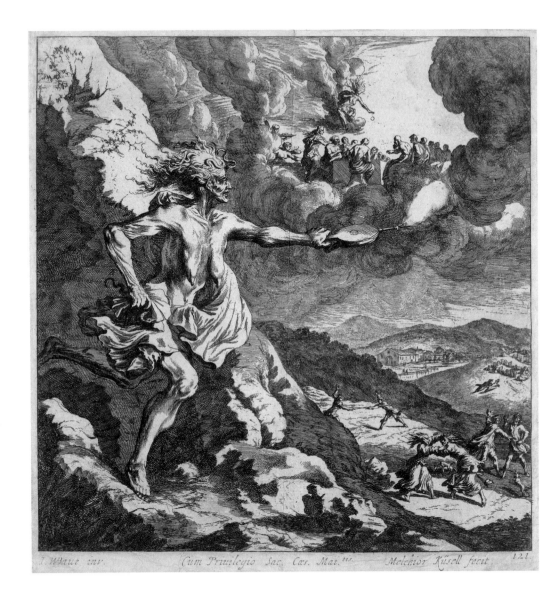

6 FREDERICK SANDYS (1829–1904)

Study for the Wood-engraving
'The Spirit of the Storm', 1860s

Pen and black ink over graphite, 15.3 × 12.6 cm
British Museum, London

The 'spirit of the storm' in this unfinished drawing for a wood-engraving is a howling witch riding the curling breakers while she conjures rain, hail and lightning from her upraised hands. Snakes are entwined in her hair and around her neck and she is accompanied by a fierce winged and horned dragon, coiling into space. Its fearsome head bears all the bloodthirsty features of a vampire bat. The billowing sail of the boat in the background is silhouetted against a dark textured sea and is reminiscent of the Greek *trireme* (galley) that is so faithfully reproduced in the gold background to Sandys's painting of *Medea* [15]. Figures of sailors cowering away from the might of the storm-witch remain unfinished in this dramatic drawing, but the exaggerated curve and counter-curve of a breaking wave has been detailed with a fine intensity of glistening pen strokes, and a frightening face can just be seen in the foreground, drowning in the tempest. Other versions of this potent subject include a more detailed drawing on a woodblock that was never cut but was reproduced for publication through the photogravure process.

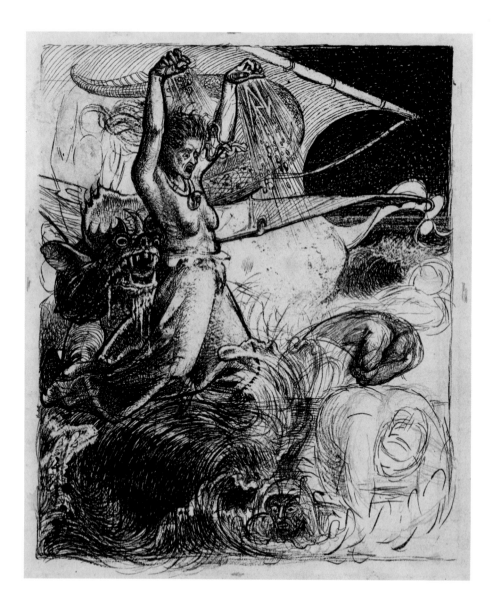

7 JOHN HAMILTON MORTIMER
(1740–1779)

Envy and Detraction, 1779
Pen and brown ink over graphite, 19 × 20.2 cm
British Museum, London

Mortimer, a brilliant draughtsman, has
humorously captured the fury of the
viper-headed witch Envy as she is crushed
by the falling figure of Detraction. This is a
study for a print entitled *Nature and Genius
Introducing Garrick to the Temple of Shakespeare*,
1779, in which both figures are trampled
by Nature and Genius, who fly to proclaim
the 'unrival'd powers' of 'Shakespear'.
David Garrick, the great Shakespearean
actor, playwright and theatre manager,
had organised a Shakespeare jubilee in the
previous decade that involved art displays as
well as performances. This set the scene for
artists to illustrate dramatic themes from
Shakespeare's plays, including witches and
fairies, leading eventually to John Boydell's
Shakespeare Gallery, set up in London in
1789 as a permanent exhibition of commis-
sioned paintings after the Bard. Garrick
funded Mortimer's set of 'Heads from
Shakespeare' but both he and Mortimer died
in 1779, the date of this group of drawings.
Mortimer modelled himself on the Italian
artist Salvator Rosa, who was believed to
have led a wild and romantic life amongst
bandits and sublime landscapes, and
Mortimer's works are connected with many
of Rosa's subjects, including sea monsters,
bandits and scenes of witchcraft.

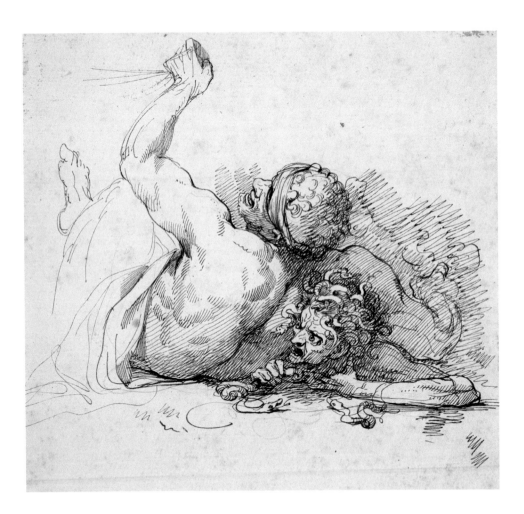

8 HANS BALDUNG GRIEN
(1484/5–1545)

Bewitched Groom, 1544–5

Woodcut, 34.6 × 20.2 cm
British Museum, London

Baldung's last mysterious print has been
subject to many interpretations. The
unconscious groom lying on the ground
in a dramatically foreshortened pose, with
his pitchfork beneath him and curry comb
near a senseless hand, has been interpreted
as a reference to a baron in a German folk
legend who was rewarded with a horse for
his pact with the Devil, and then kicked to
death. Undeniably the figure leaning in at a
window with her breasts bare is a cackling
witch: she holds a flaming torch, the sign
of Venus that occurs in so many early
images of witches. The unicorn shield on
the right of the stable opening is Baldung's
family escutcheon the inclusion of which
has inspired many interpretations of the
symbolic significance of the print for the
artist. In 1534 he had created three curious
woodcuts of horses in woodland, mating
and fighting. It is generally accepted that
the horses symbolise human sexuality.
Aristotle considered horses to be the
'most salacious of animals' and mares
were traditionally regarded as sexually
voracious.

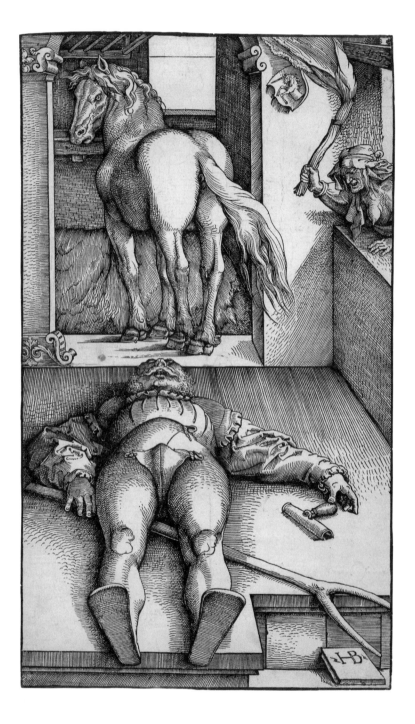

9 JOST DE NEGKER (c.1485–c.1544)

The Temptation of St Anthony, c.1500–20

Woodcut, 37 × 26 cm
British Museum, London

A bearded Saint Anthony is seated heavily
on the ground, accompanied by his usual
attribute the pig (a symbol of greed, but here
with a bell in one ear) and raising his two
fingers either to bless or to repel the three
demons that tempt him in his landscape
retreat. The nude figure with devil's horns
holds a vase while turning to her long-haired
companion who appears to be supporting
a pregnant belly. Between the two female
figures a composite monster with a long tail
brandishes a bowl of coins, and his demonic
lion face is not unlike the Devil who peeks out
from the flames in Dürer's *Four Witches* made
a few years earlier. The long single breast
with its extended teat proclaims this sexually
ambiguous creature to be as malevolent as a
witch. The wonderful clarity of the woodcut
technique, with its differentiated codes for
representing tree foliage, clouds, moun-
tainsides and rock formations, prevents the
crowded composition from collapsing into
confusion. The Flemish-born printmaker and
publisher Jost de Negker worked in Antwerp
until about 1508 when he was put in charge
of the Emperor Maximilian's block-cutting
establishment in Augsburg, which was
responsible for extensive print publications
designed by artists such as Dürer and Hans
Burgkmair (1473–1531).

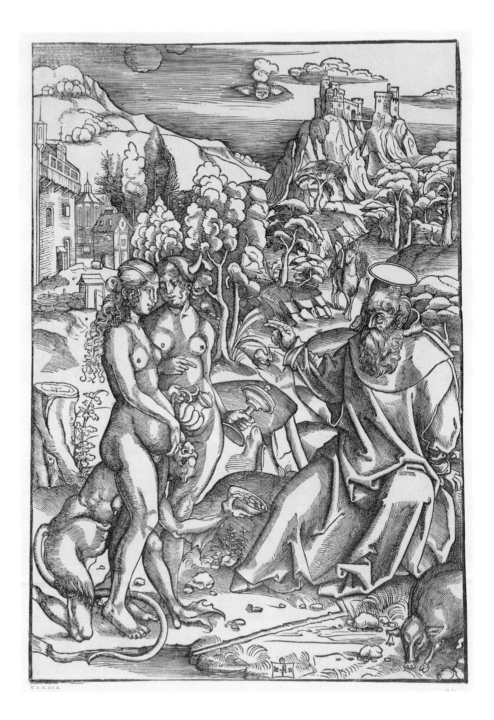

10 AFTER DAVID TENIERS
THE YOUNGER (1610–1690);
ETCHED BY JACQUES-PHILIPPE
LE BAS (c.1707–1783)

The Temptation of St Anthony, c.1745–7

Etching, 37 × 49 cm
Ashmolean Museum, Oxford

This late reverse print from a French publisher, made a hundred years after the original painting by David Teniers the Younger, indicates the enduring popularity of the artist's representations of witchcraft and saints tormented by demons. The painting is in the Musée des Beaux-Arts in Lille and is one of about two hundred versions of the *Temptation of St Anthony* to have come out of Teniers's busy workshop. A prolific painter of peasant life, Teniers also painted alchemists in their workshops and was admired as much in Spain as in his native Flanders. He was influenced by his father-in-law Jan Brueghel (1568–1625), the son of Pieter Bruegel the Elder, as well as by Frans Francken II, who was also known for witch paintings. Saint Anthony is usually represented in Teniers's paintings in a grotto tempted by lust, symbolised by a beautiful, well-dressed whore, or by greed represented as a pig, as well as a whole host of other pestering demons. In this open-air version a monkey-faced demon with clawed bird's feet presents the beautiful witch, holding a glass of wine, to the distracted bearded saint, who is praying at a stone altar.

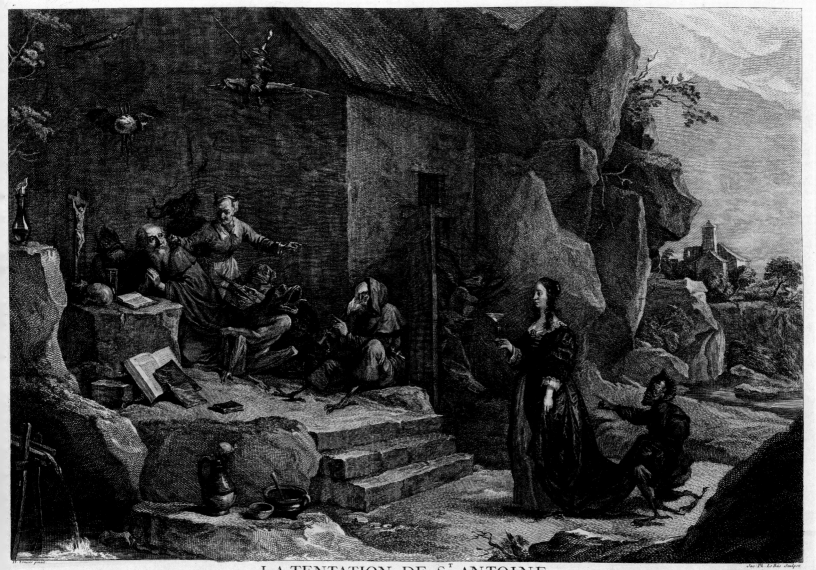

LA TENTATION DE St. ANTOINE

Estampe gravée d'apres un tableau peint par David Teniers de l'Hôtel de Matignon, appartenant à Monseigneur le Duc de Valentinois, Pair de France.

41.e Teniers

A Paris chez Jac. Ph. Le Bas graveur du Cabinet du Roy au bas de la rue de la Harpe.

11 FRANCISCO DE GOYA Y LUCIENTES (1746–1828)

Mucho hay que chupar (*There is Plenty to Suck*), *Los Caprichos*, plate 45, 1799
Etching and burnished aquatint, 20.4 × 15 cm
British Museum, London

Los Caprichos (*The Caprices*) was Goya's first complete series of prints (he began to make etchings in the late 1770s) published when the profoundly deaf artist was fifty-three, marking a brief period of enlightenment in Spanish politics. The drawings for some of the eighty etchings were known as *Sueños* (*Dreams*) and the first ten employ witch imagery in satirical commentaries on superstition and social, religious and political abuses. The image originally designed as a frontispiece, *El sueño de la razón produce monstruos* (*The Sleep of Reason Produces Monsters*), became plate 43 in the published series, which was soon withdrawn from circulation by Goya. A newspaper announcement of the publication expanded the inscription of *Sueño* 1: '[The author's] intention is to banish harmful common beliefs and to perpetuate … the sound testimony of truth.' Plate 45, based on a red chalk drawing, expands on the wordplay 'to suck', a current colloquial expression for corruption that also implies 'to rob'. A commentary, once believed to have been written by Goya himself, explains: 'Those who reach eight suck little children; those under eighteen suck grown-ups. It seems that man is born and lives to have the substance sucked out of him.' Witches eating babies belong to a long tradition, emphasised by the presence of vampire bats.

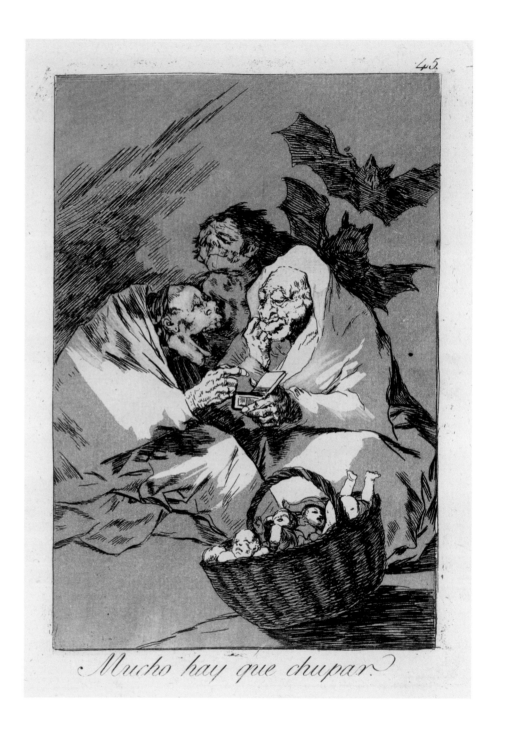

Mucho hay que chupar

12 FRANCISCO DE GOYA Y LUCIENTES
(1746–1828)

Sopla (Blow), Los Caprichos, plate 69,
1799

Etching, aquatint, drypoint and burin, 21 × 14.9 cm
British Museum, London

The foulness of witches is the theme of this
potent print. In the background, below a
winged harpy, is a menacing witch with two
babies in her arms that she is about to devour
with a horrible smile of greed and pleasure.
There are two preparatory drawings associated
with this print, *Sueño* 7 and an earlier rough
pen and ink sketch from Goya's *Madrid Album*,
with the caption 'Auntie Bellows lights the
fire. Witches about to gather again', 1796–7;
the witches are referred to as '*Brujas*' (hags/
witches) in a chalk inscription in Goya's hand.
The screwed up top-knot of hair in the drawing
and print gives no indication of the gender of
the sexually indeterminate tall figure holding
the rigid, farting infant. As in earlier works by
Baldung and de Gheyn, visceral fumes are used
to light a flame and signal a crude relationship
with fornication as well as the 'hot air' of
specious beliefs. A Spanish proverb of the time
states: 'Man is fire, woman is tow, along comes
the Devil and blows'.

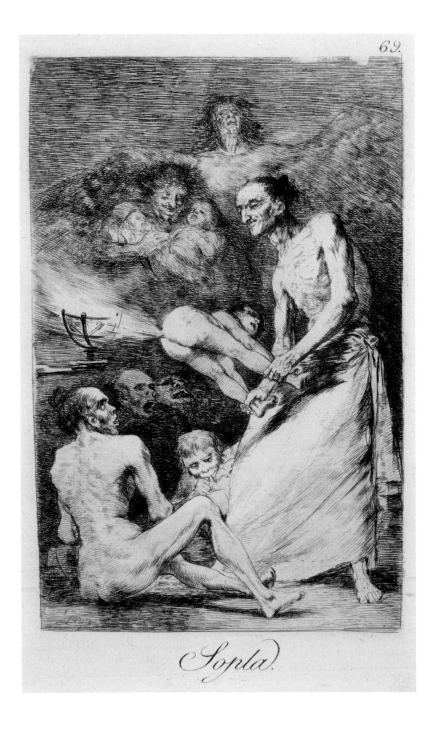

13 WILLIAM BLAKE (1757–1827)

The Whore of Babylon, 1809

Pen and black ink and watercolour, 26.6 × 22.3 cm
British Museum, London

Between 1799 and 1810, Blake made a number of watercolour paintings of biblical subjects for his patron Thomas Butts. This intense work, acquired as early as 1847 for the British Museum, illustrates Revelation 17: 1–4, a passage that had also been the subject of a 1496 apocalyptic woodcut by Albrecht Dürer. Closely following the words of the King James Bible, it depicts the judgement of 'the great whore … with whom the kings of the earth have committed fornication, and the inhabitants of the earth have been made drunk with the wine of her fornication'. She sits upon a scarlet-coloured beast with seven heads and ten horns, 'decked with gold and precious stones and pearls, having a golden cup in her hand full of abominations and filthiness of her fornication'. Blake identified Babylon with London and the heads of the monster are devouring the swarming 'peoples of the earth'. The stream of creatures swirling out of the chalice recalls the monsters begat by Goya's *Sleep of Reason*. Clarity of drawing is dominant, with a contrast between the firm outlines of the crowned harlot in her oriental-style trousers and the intensely shaded contours of the body of the Beast, its bestial heads turning between its prey and the sulky beauty of the apocalyptic whore.

14 GIOVANNI BENEDETTO CASTIGLIONE (1609–1664)

Circe Changing Ulysses's Men into Beasts, c.1650

Etching, 21.5 × 30.5 cm
British Museum, London

In Book x of the Greek *Odyssey* Homer told the story of Odysseus and the sorceress Circe who turned his sailors into swine. Ovid reprises many tales of her wicked spells in the Latin verse of the *Metamorphoses*. She either collects herbs and poisonous plants in the woods and fields of her magical island or is enthroned on a 'splendid chair in a beautiful apse and wearing a dazzling robe wrapped round with a golden cloak' in her sumptuous palace. In this popular etching with its rich painterly technique, the Genoese Baroque artist Castiglione, a noted printmaker, pictures Circe in contemplative mood amongst the romantic ruins of classical antiquity, with a wand in her hand before piles of *grimoires* (books of magic spells and diagrams for the use of necromancers) and occult signs on the ground. Discarded armour lies before her, and the transformed intruders parade in the forms of cloven-hoofed sheep, goats and deer, with a dog and a peacock to guard them. In his mid-century travels Castiglione came into contact with Salvator Rosa, and both artists reflect a similar fascination with fantastical *capriccio* etchings of exotic 'oriental' figures, or philosophers and magicians in romantic landscape settings.

15 FREDERICK SANDYS (1829–1904)

Medea, 1866–8

Oil on wood panel, 61.2 × 45.6 cm
Birmingham Museums and Art Gallery

Sandys carried out meticulous research for this commissioned painting inspired by William Morris's lengthy poem *The Life and Death of Jason* (1867). His model was his gypsy mistress Keomi: her extremely arresting, if ambivalent expression, that roused so much comment when it was exhibited, still demands attention. Lit from below by the flaming brazier into which she is pouring liquid from a glass beaker, Medea is depicted concocting the poison that will destroy Glauké, her rival for Jason's affections. The mysterious objects on the marble parapet in front of her include a pair of copulating toads, a red thread and an abalone shell filled with blood. Some of these finely delineated items refer to Morris's poem, such as a bowl 'polished bright / Brazen, and wrought with figures black and white' and the 'strings as red as blood' with which various objects are tied within her wallet for herbs and magical objects. The gold background is as reminiscent of fashionable Japanese screens for domestic interiors as it is of the gold backgrounds of the early Italian 'Primitive' painters who greatly influenced the Pre-Raphaelites. In it is depicted Jason's ship, the Argo, as it 'sped swiftly 'twixt the dark and whispering trees' accompanied by winged figures that could be harpies.

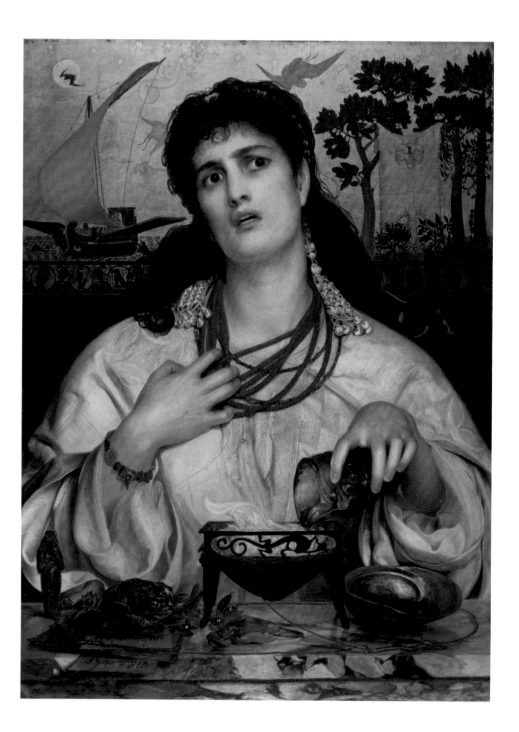

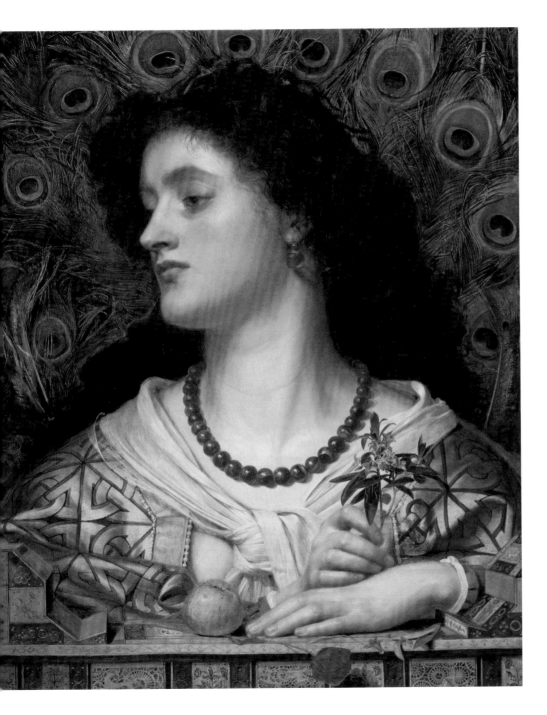

16 FREDERICK SANDYS (1829–1904)

Vivien, 1863

Oil on canvas, 64 × 52.5 cm
Manchester Art Gallery

In Alfred Lord Tennyson's cycle of narrative poems *Idylls of the King* (1856–85) malicious Vivien, the sorceress, deceives the ageing Merlin into revealing his magic to her, a charm 'of woven paces and of waving hands'. She follows him into a wooded retreat, where he refutes all her calumnies against the knights of King Arthur's Round Table, but finally yields to her hypocritical caresses and importunate demands. The scorn of Vivien's final riposte 'O fool' as she leaves him unconscious in the grove is possibly reflected in the contemptuous but haughty expression of Sandys's portrait of his gypsy mistress Keomi as Vivien. With her dark hair framed by peacock feathers, she wears a partially revealing golden robe with an elaborate interlocking design and a carnelian necklace and earring. Like other bust-length paintings of women by Sandys, possibly influenced by his friend Dante Gabriel Rossetti, she is represented behind a marble parapet reminiscent of the early Renaissance. This framing device serves to distance her from the viewer and to enhance the fine modelling of her flesh and rich apparel, and the painstaking attention to texture. She holds a twig of poisonous daphne or oleander, and an apple, dried herbs and a rose adorn the parapet with its tile decoration reminiscent of some mythical and magical past.

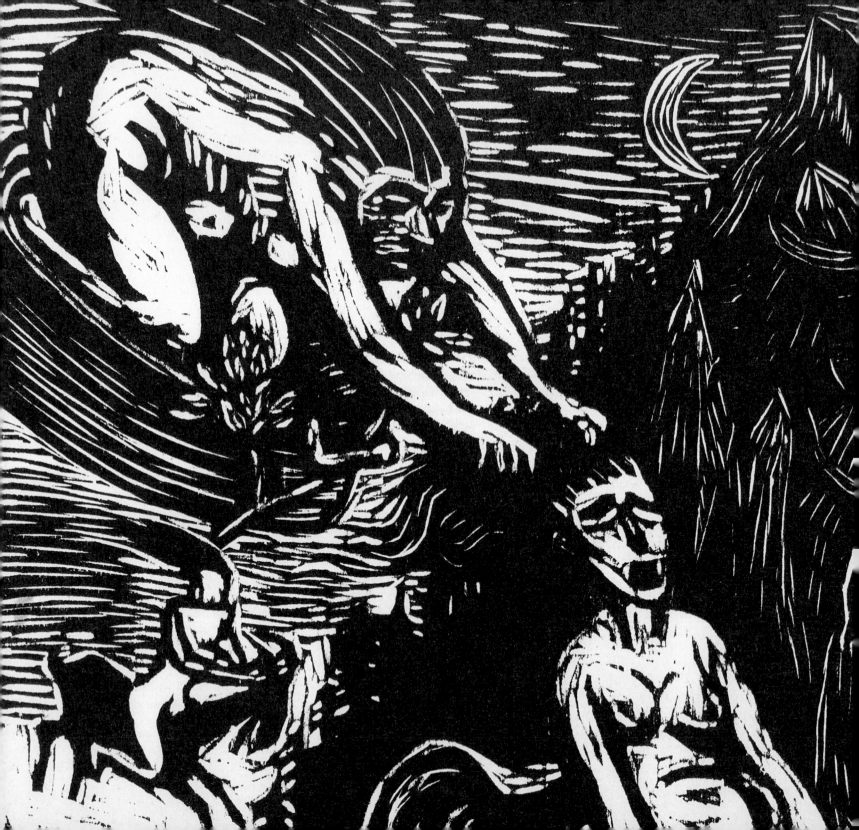

UNNATURAL ACTS OF FLYING

< Detail from [29]

Witches are human and cannot defy gravity like Satan, the rebel angel, and his demons. In order to fly over vast distances to conduct their nefarious deeds or attend witches' sabbaths they were thought to rub their bodies with a magical paste made from the fat and ground bones of unbaptized infants, as well as other disgusting ingredients boiled in a cauldron. Such recipes for magical flight were described in the infamously misogynist *Hammer of Witches* (*Malleus Maleficarum*) (1486), one of the best known early treatises on witchcraft, and were elaborated in later books on demonology. Although witches confessed under torture in witch trials to flying they often explained that the flying happened while they were asleep.

In early illustrations, witches fly on pronged cooking forks, sticks and besom brooms as well as on dragons, horned goats or monstrous incarnations of the Devil. From the seventeenth century onwards they are depicted as flying up chimneys on broomsticks when leaving the foul and crowded kitchens where they have been cooking up their potions and unguents and preparing for incantations.

In classical antiquity, witches, as devotees of Diana and Hecate, flew on nocturnal 'wild rides' across the skies, as a metaphor for untrammelled sexuality. In mediaeval and Reformation Germany they rode with hordes of the risen dead towards the mystical Venusberg mountain. Later they mounted winged demon horses in terrifying pursuit of innocent victims when they congregated on *Walpurgisnacht*, or snatched an innocent child. The connection between flying and sexuality has often been picked up by artists over the centuries, using broad phallic humour for satirical purposes.

Even before the Enlightenment jurists and commentators expressed scepticism about the physical reality of flying, suggesting that these were guilty *dreams* rather than actual events. In visual representations of witches the distinctions between reality, metaphor and dream are blurred. Goya's etchings of flying witches in *Los Caprichos* (1799), are based on his set of drawings entitled *Sueños* (*Dreams*). They employ dynamic metaphors of flight in savage commentaries on social conditions of the time. His witches are sometimes sexually ambivalent, and do not always need the aid of demons to float in the sky and spread fear and horror.

17 ALBRECHT DÜRER (1471–1528)

Witch Riding Backwards on a Goat,
1500

Engraving, 11.6 × 7.2 cm
British Museum, London

There are many contradictory symbols
in this very famous print that influenced
centuries of witch art. The shrieking old
hag rides backwards on the goat with her
broom and spindle between her legs, her
wild hair streaming out in her direction of
travel. The goat is an embodiment of the
Devil, and also a symbol of lust, and the
chubby winged cupids with their wands
appear to restrain the flying goat, while
the infant putto in the foreground turns
on his head in a celebration of the upside
down. Even Dürer's usual monogram is
reversed. Witchcraft is understood to be
the reversal of normal ethics and religious
practices, and cupids who promote love
are here related to an old hag whose
sexuality belongs to the Devil, also a sign
of perversity. Lines of rain and hailstones
in the upper left corner remind us that
witches are committed to raising storms
and spreading destruction.

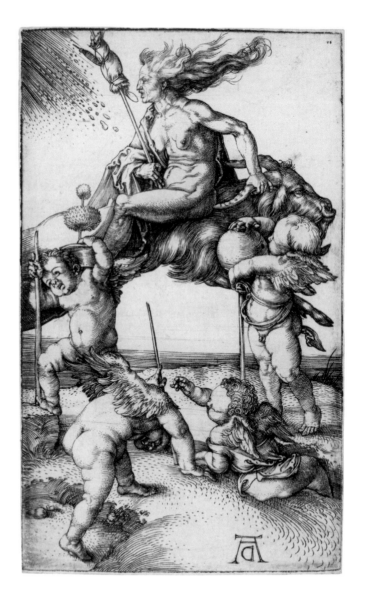

18 AFTER PIETER BRUEGEL THE ELDER
(*c*.1525–1569); ENGRAVED BY PIETER VAN DER
HEYDEN (*c*.1530–*c*.1575)

St James and the Magician Hermogenes, 1565

Engraving, 21.7 × 29 cm
British Museum, London

The haloed Saint James the Apostle, identified by his cloak, with a pilgrim's staff and scallop-shell hat, can only just be discerned as the main figure standing in front of the bubbling and smoking central cauldron. He visits the ancient magician Hermogenes seated behind a small fuming vessel on a tripod. The magician's servant Philetus, who has been fixed to a three-legged stool by a magic spell, huddles to the right of the cauldron near a witch who shakes a sieve to create storm spells; there is a shipwreck taking place in the dark middle distance. A row of little monkeys warm themselves at the fireplace, a witch flies up the chimney, and another witch emerges out of the top of the chimney. On the mantelpiece, serving as candelabra, is a 'hand of glory', severed from a hanged criminal, and the sky is filled with flying witches and demons, squalls and tempests. A magician is making magic within a circle on the right and in the underground cellar two monsters dismember a cadaver. Many of these fantastic inventions were borrowed by Bruegel from the fantastical compositions of Hieronymus Bosch.

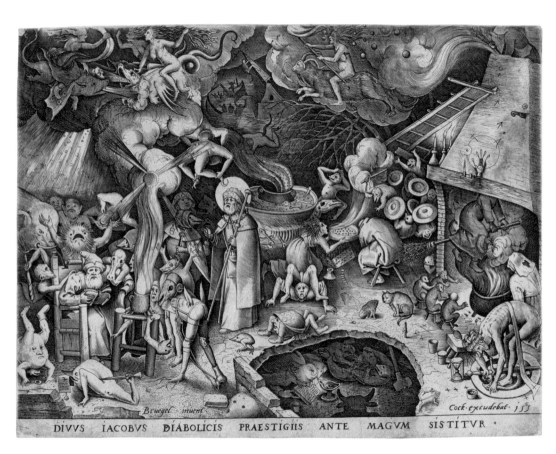

DIVVS IACOBVS DIABOLICIS PRAESTIGIIS ANTE MAGVM SISTITVR ·

19 HANS BALDUNG GRIEN
(1484/5–1545)

Witches' Sabbath, 1510

Colour woodcut from two blocks, tone block
orange-brown, 37.1 × 25.4 cm
British Museum, London

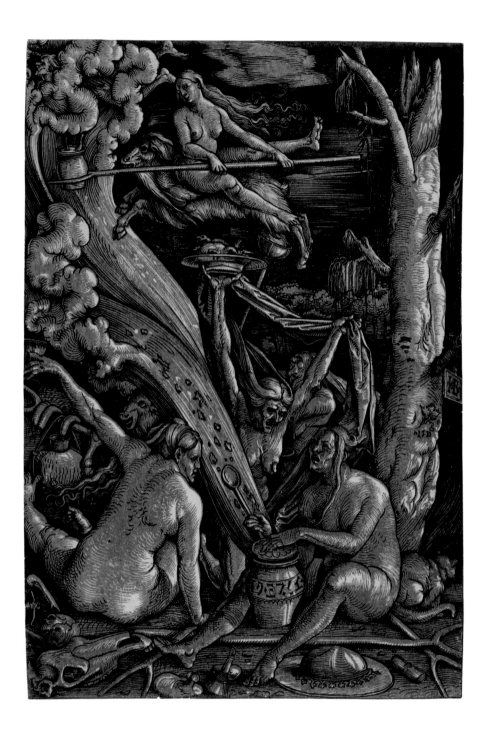

This preparation for the sabbath, rich in sexual symbols and visual satire, takes place in a gloomy forest. The crowded composition is held together by a gnarled pine tree on the right and the thick fumes of polluted smoke emerging from the pot held between the knees of a naked hag. The pseudo-writing on her vessel refers to the ancient origins of magical cults. She communicates with a gesticulating younger witch; the poses of the figures would be borrowed by many later artists. The witch riding a goat backwards in the air holds a pot in a forked kitchen stick, while a gaunt hag in the background holds up a torch to be lit from the heat of the goat's genitals. The theme of 'cooking up' devilry is represented by the satanic fowl on a platter held aloft by the central screaming hag. The sausages cooking on a stick on the left are deliberately phallic, a visual joke that Baldung repeated in other witch compositions. The very precise organisation of implements on the ground in front includes a convex mirror for trapping demons in divination rituals.

'Chiaroscuro' woodcuts employing two blocks were richer in colour than monochrome prints and were highly prized by collectors.

20 LUCAS CRANACH THE ELDER (1472–1553)

Allegory of Melancholy, 1528

Oil on panel, 112.5 × 71 cm
Private Collection on long loan to the Scottish
National Gallery, Edinburgh

The absent-minded figure of Melancholy
is distractedly whittling a wand, with her
hair flying out to one side as she ignores
the gambolling nude infants holding
sticks and playing with an irritable dog.
On the floor around her are some of the
symbols associated with geometry and
agriculture and the planet Saturn, the
planet associated with the melancholic
humour. She is suffering from the
'sloth' that accompanies melancholy
and the Devil has responded by filling
the ominous sky with nude witches,
variously riding goats, deer, lions, pigs
and a cow, while a hooded demon makes
off on a horse. The curious mountain
on the right has been associated with
the Venusberg, the sinful mountain that
attracted the 'wild horde' of phantom
riders on a sexual quest. Cranach was very
close to the Protestant reformer Martin
Luther who believed that 'all sadness,
plagues and dejection come from Satan'.
Cranach painted four versions of this
subject, and although this is often known
as the 'Orange Melancholy', the fruit in
the tree are probably the apples of Eve's
unchasteness.

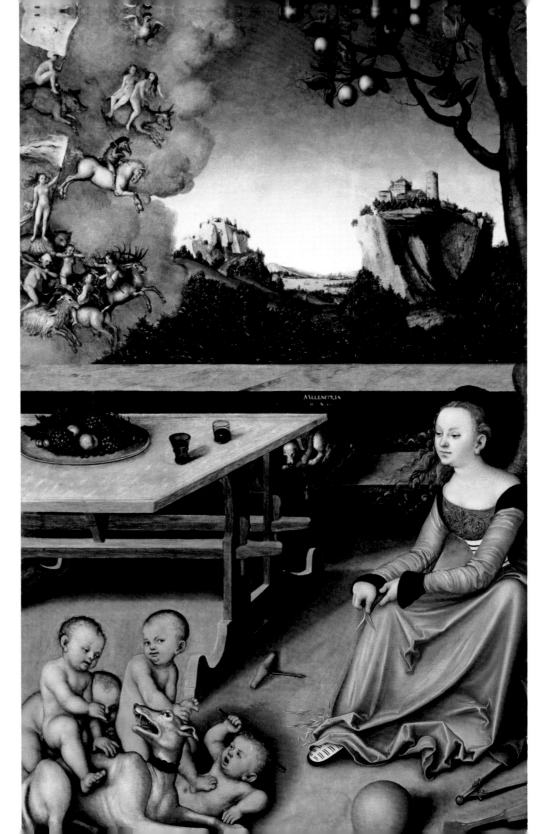

21 UNKNOWN ARTIST

Fantastic Horse and Rider, c.1600
Brown pen, ink and grey wash, 27.2 × 18.1 cm
Victoria and Albert Museum, London

Little is known about this fine drawing of a shouting naked figure, bearing a smoking cauldron on a forked kitchen stick as she rides a leaping horse, with hair and mane blowing wildly in the direction in which they are travelling. She has an exaggerated goitre on her neck and the musculature of her upper torso suggests the many-breasted, if inert, cult statues of Diana of Ephesus, or indeed the Eastern 'Great Mother' goddess, Cybele. The sensuality of the nude body fixed to the sweating flank of the horse accentuates the customary association of witchcraft with sexual excess. Horses were ridden by the 'wild hordes' who followed the goddess Diana, as described in mediaeval texts, and they also appear in the backgrounds to Lucas Cranach's paintings of *Melancholy* [20]. The nude figure is definitely a witch and the assumption that this drawing is German is strengthened by its relationship to a fine pen and ink drawing of *Deaniera being Abducted by the Centaur Nessus*, sometimes attributed to Albrecht Dürer, in the collection of the École des Beaux-Arts, Paris, in which the feisty abductee faces the opposite way as she fights her equine abductor.

22 JAN DE BISSCHOP (1628–1671)

A Witch Riding through the Air on a Dragon, 1643–71

Pen and ink wash, 16.3 × 13.3 cm
British Museum, London

Jan de Bisschop was a learned Amsterdam advocate with a passion for art, and this ink copy is presumably after an earlier, now lost print, possibly by the Netherlandish artist Lucas van Leyden (*c*.1494–1533); L for Leyden appears at the bottom of the drawing. The hooded witch with her draperies curling out into the storm in the style of an earlier age, is chanting a spell as she rides side-saddle and barefoot on a broomstick intertwined with a dragon. Her *grimoire* with dangling tassels is held up in front by the obliging dragon in the manner that a priest might read the Bible from a lectern. The scene of destruction below, depicted in a slightly lighter brown wash, shows a windmill on fire, a heavy storm bending the trees around villages and town, and a number of distraught people rushing towards the disaster. De Bisschop had developed an ink that was capable of a huge range of intensity, and these contrasts add to the drama of the composition.

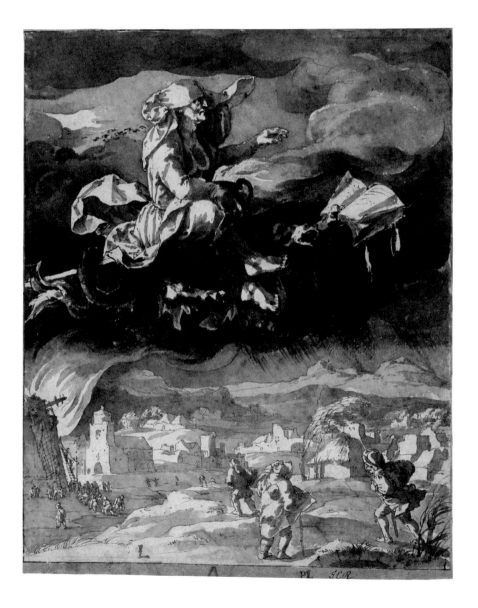

23 POSSIBLY AFTER PARMIGIANINO (GIROLAMO FRANCESCO MARIA MAZZOLA) (1503–1540); ETCHED BY BERNARD PICART (1673–1733)

The Witches' Sabbath; A Hooded Witch Rides a Monster, 1732

The Witches' Sabbath; A Hooded Witch Rides a Colossal Phallus, c.1732

Two etchings, 15.4 × 9.7 cm and 14.5 × 9.5 cm
British Museum, London

Named after his birthplace, Parma, the mannerist painter Parmigianino was also an exceedingly prolific draughtsman and etcher. He worked both in Rome and Bologna as well as in his native city. Collectors' esteem for his fluent drawings meant that they were frequently copied, even centuries later. Towards the end of his brief life he reputedly became fascinated with alchemy and he addressed the subject of enchantresses, in drawings such as *Circe and the Companions of Ulysses*, c.1527 (Galleria degli Uffizi, Florence) and *Saturn Devouring his Infants*, (Musée du Louvre, Paris). The publisher and printmaker Picart, who moved between Paris and the Netherlands, was a Huguenot, whose widow published these prints posthumously in the controversial *Innocent Impostures; or, A Collection of Prints after Various Celebrated Painters* (1734). In the print that claims to be after a drawing in an Amsterdam collection, the hairy steed with its truncated back leg has a monster's head. This has been transformed into a large phallus held aloft by a winged and horned devil in the second print. It is mounted from behind by a many-dugged demon who clings to the shoulder of the booted and hooded witch brandishing a large distaff and spindle.

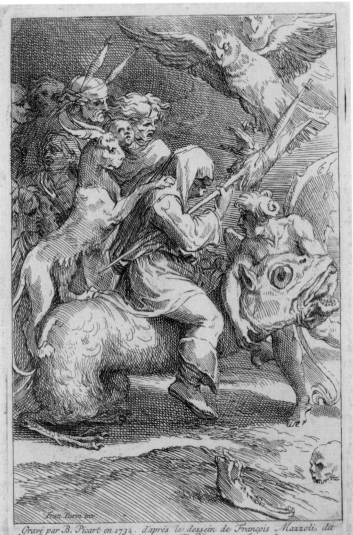

Gravé par B. Picart en 1732. d'après le dessein de François Mazzoli, dit
le Parmesan, qui est au Cabinet de Mr. Rutgers à Amsterdam.

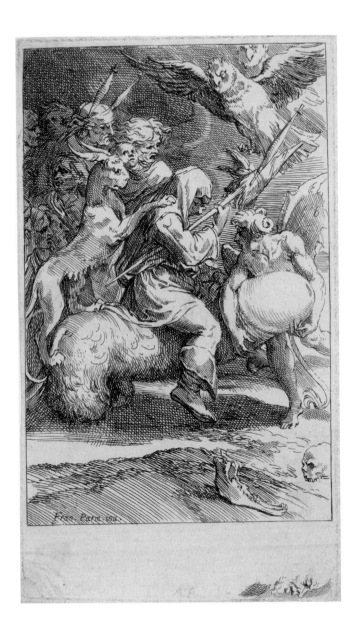

24 FRANCISCO DE GOYA Y LUCIENTES (1746–1828)

Si amanece; nos vamos (*When Day Breaks we will be Off*), *Los Caprichos*, plate 71, 1799, trial proof

Etching, burnished aquatint and burin, 19.7 × 15 cm
British Museum, London

The faces of these distorted hags appear in other etchings by Goya, suggesting that the 'Enlightened' eighteenth century still endorsed the cruel belief that ugliness equals evil and was an indicator of inner wickedness and malevolence. These were the teachings of Johann Kaspar Lavater (1741–1801), the Swiss founder of physiognomics, a close friend of Fuseli (who translated Lavater's writings into English), and who was also read in Spain by Goya. The dark gesticulating figure appears to be sitting on the rump of some larger creature on whose side are perched children. The dark sky speckled with stars has been created by aquatint, a printmaking technique used for tonal effect. Goya positions the figural group on the left of the image, allowing the expansive gestures of the show-off witch, with her nose raised in a curiously arrogant expression, to dominate the print. The composition is not unlike that of *Caprichos* 11, *Muchachos al avío* (*Lads Making Ready*), where a group of smugglers, perched on rocks, prepare for illicit deeds. Their clothing proclaims their profession, just as witch nudity proclaims evil. Some commentators have interpreted the coming dawn as the 'luminous splendour of science' that banishes superstition.

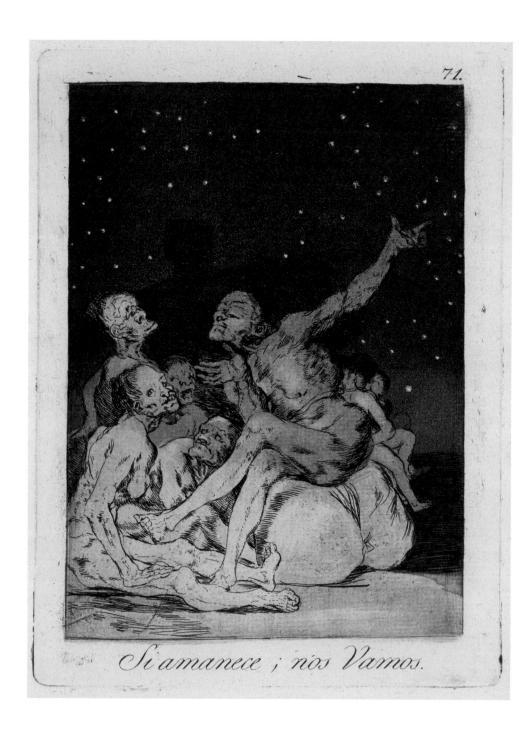

25 FRANCISCO DE GOYA
Y LUCIENTES (1746–1828)

*Allá vá eso (There it Goes), Los
Caprichos,* plate 66, 1799, trial proof
Etching, aquatint and drypoint, 20.8 × 16.4 cm
British Museum, London

An old, bony hag, one of Goya's sexually
indeterminate witches, brandishes a
serpent-entwined crutch for a scrawny
cat which, every hair raised in fury, clings
to the snake. The partially hidden young
witch behind spreads huge bat wings, so
that each member of this horrible group
is simultaneously exploiting and fighting
each other while bound into dependency.
A peaceful landscape with farm buildings
unfolds below. This is more intensely
portrayed in the expressive preparatory
drawing, *Sueño* 5, inscribed as a witch
teacher giving a lesson (*Bruja maestra dando
lecciones*). Novice witches being taught evil
ways by old hags constitute a sub-theme
in many of the witch subjects of the
Caprichos; perhaps a cynical commentary
on the Enlightenment's preoccupation
with learning. A second *Sueño* is entitled
Ensayos (*Trials*) and depicts a young
female witch rising into the air, painfully
holding a young man by the ear as he floats
awkwardly in a horizontal position. The
theme of apprentice witches continues in
children's literature today.

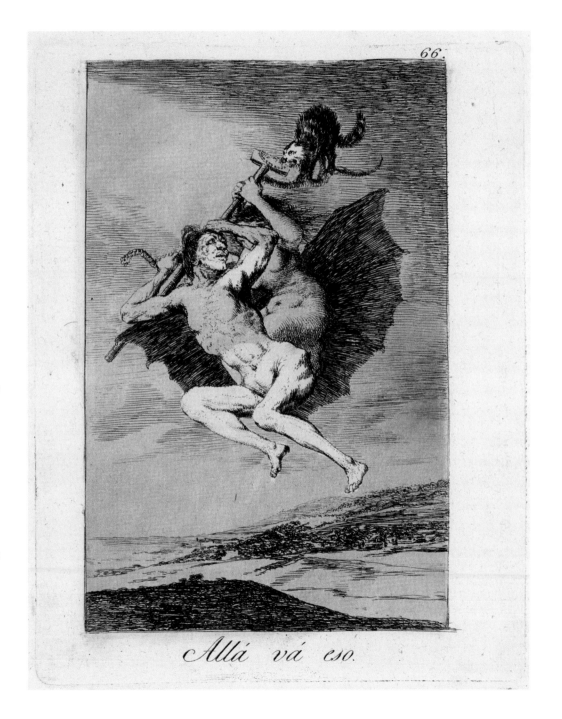

Allá vá eso.

26 FRANCISCO DE GOYA Y LUCIENTES (1746–1828)

Linda maestra! (*Pretty Teacher!*), *Los Caprichos*, plate 68, 1799, working proof
Etching, burnished aquatint and drypoint, 19.7 × 15.5 cm
British Museum, London

Goya often plays on puns and word meanings in his images, but neither the commentaries on the drawings nor the published titles of the prints are ever completely straightforward or literal: they offer tantalising clues and deliberate ambivalence of interpretation.

The contrast between the shapely young witch and her ancient teacher is key to this image. She is clutching her hair as they ride on a shared broomstick, rising above a night-time landscape accompanied by an owl (*búho* both means night owl and is the slang term for streetwalker). Care has been given to the drawing of the young witch's genital area as she straddles the stick with legs wide apart, and the contemporary (Museo del Prado) commentary reads: 'The broom is one of the most necessary implements for witches, for they are not only great sweepers [thieves]…but at times they turn the broom into a saddle mule [a dildo].' A slang meaning of the Spanish *volar*, to fly, is to have an orgasm, which is the meaning stressed in every explanation of the image published during Goya's time. The 'pretty teacher' is the hideous old witch bawd, whose face is illuminated so that we can read her wrinkles and hairy chin. Her aim is to corrupt the younger woman.

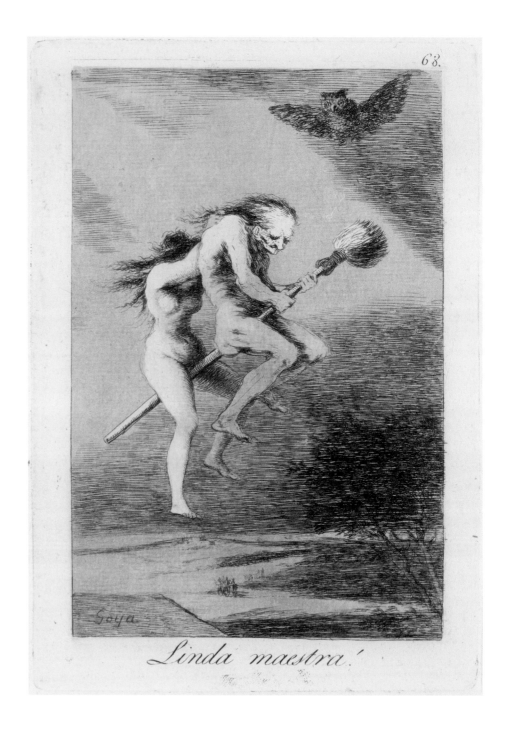

27 FRANCISCO DE GOYA
Y LUCIENTES (1746–1828)

Donde vá mamá? (Where is Mother Going?), Los Caprichos, plate 65, 1799, trial proof
Etching, aquatint and drypoint, 20.7 × 16.5 cm
British Museum, London

Mamá witch is an excessively large and frowsty matron with a doughy belly, so laden with crimes that she requires any number of demonic creatures to keep her in the air: including a cat familiar carrying a parasol, and three demons of indeterminate gender, the lowest one riding an owl, supporting him/her in the crotch. The print is very close to the original drawing *Sueño* 9 or '*Bruja poderosa*', with the top-heavy group hardly able to lift off the ground, either to proceed to a black mass or commit acts of destruction on the innocent townscape below. Goya often uses the image of one figure riding on the shoulders of another, for example, a prostitute on the shoulders of a satyr in *Sueño* 3, which was reworked a number of times to depict witches confronting priests belonging to the '*Devout Profession*' in the hard-hitting *Caprichos* 70.

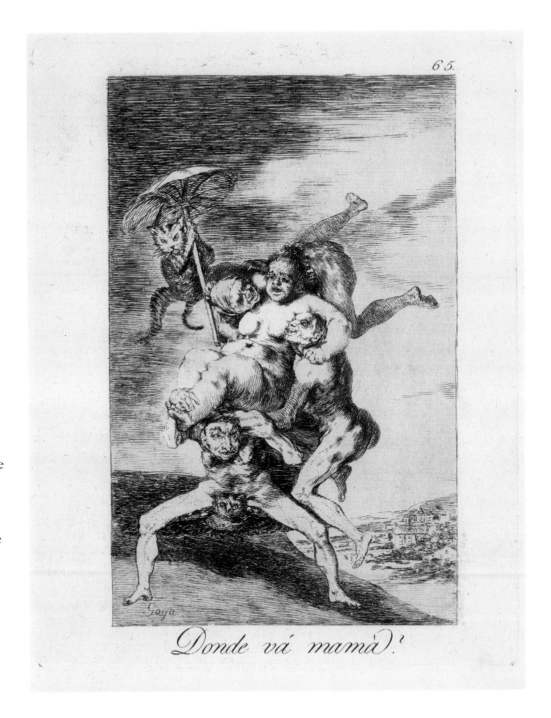

65.

Donde vá mamá?

28 PAUL SANDBY (1731–1809)

The Flying Machine from Edinburgh in One Day Performed by Moggy Mackenzie at the Thistle and Crown, 1762

Hand-coloured etching, 26.9 × 23 cm
Scottish National Portrait Gallery, Edinburgh

This etching attacks the supposedly extraordinary emigration of Scots to England under the patronage of John Stuart, 3rd Earl of Bute (1713–1792), who rose to power as Prime Minister in the reign of George III. Lord Bute was the subject of numerous satires and caricatures, as were the Scots who secured jobs under his patronage. A contemporary account described this work: 'This shews that "Scotch" Politicks are of no more Value than a Broomstick; and that an Old Woman and "Scotch" Pedlar, are no more to be minded than Witchcraft.' The barefoot tatterdemalion figures sharing the witch's broomstick are perhaps not unaware that it ends in a large curved phallus, suggesting that the power to leave 'The Garden of Eden' can also tempt members of an underclass. Sandby, a prolific topographical artist, came to Scotland in 1747 as chief draughtsman of the Military Survey. He supervised ordinance maps but also produced an enormous array of watercolours, oils, drawings and prints celebrating landscapes, buildings and local customs, eventually becoming a celebrated teacher and founder member of the Royal Academy, London.

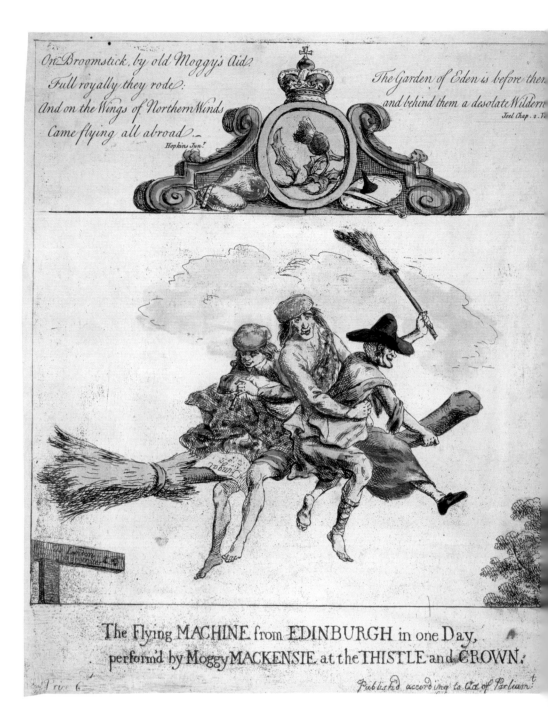

29 ERNST BARLACH (1870–1938)

Flying Witch, 1922, plate from
Walpurgisnacht by Johann Wolfgang
von Goethe (1749–1832)

Woodcut, 18.8 × 14.4 cm
Victoria and Albert Museum, London

This image of a flying witch (*Hexenritt* or
Witch Ride) employs all the traditional
motifs of broomsticks and goats, but is
here translated into the bold modernist
language of the twentieth century. It
is one of the sculptor and printmaker
Barlach's designs for an adaptation of
Goethe's *Faust* Part 1, which was pub-
lished as a portfolio of twenty woodcuts.
The title page depicts an abandoned
witch with her dress raised against a
crescent-moon night sky. Scenes include
a befuddled and skinny old hag, with
wild hair, on the ground in a wicker
basket, while her young companion flies
towards the festivities; an extraordinary
cloaked figure flying precipitously on a
table (an owl's nest); and a bishop taking
to the sky above a speeding devil with
a curly tail. Other plates picture Faust
and Mephistopheles striding up the
Blocksberg mountains where Lilith,
Adam's wife, accompanied by a boar,
attends wild celebrations and a cloaked
Faust dances wildly with a young witch.

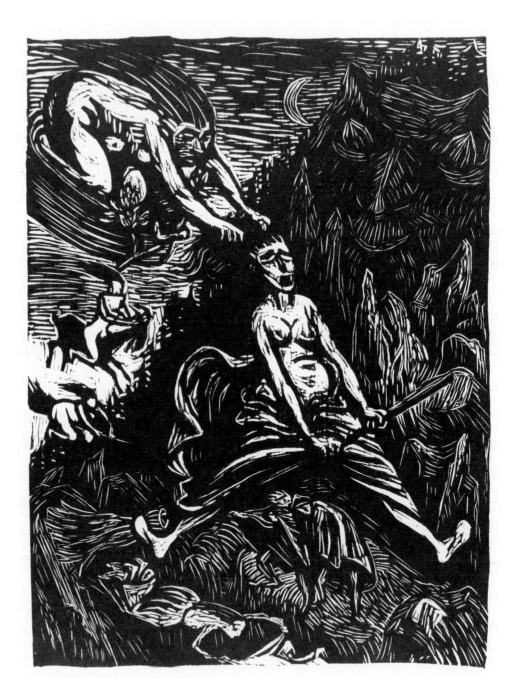

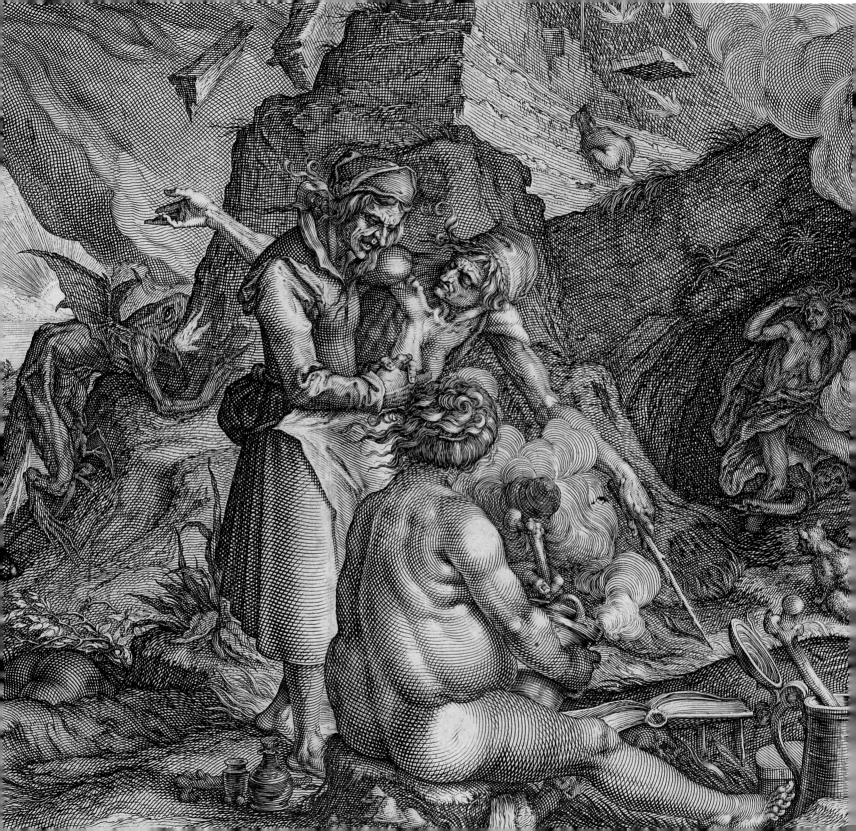

WITCHES' SABBATHS &
DEVILISH RITUALS

< Detail from [30]

The peak of the European witch-hunts was from about 1550 to 1630. This coincided with a period of political, religious and economic turmoil, and was marked by influential demono-logical treatises. The French judge Pierre de Lancre's (1553–1631) investigations in south-western France, and the subsequent executions, promoted prurient information about the rites of witches' sabbaths as perversions of Catholic masses. Lurid details of satanic worship and copulation with devils, banquets of carrion flesh, the making of philtres and poisons in cauldrons and the corruption of children, not only influenced visual images but became the very stuff of the confessions of accused witches across Europe.

Witches who fly in hordes to attend sabbaths are seen as being part of a female collectivity or coven that threatens the social order. This is depicted as unbridled female wickedness, orchestrated by the Devil with whom they have signed a pact and who has stamped their bodies with witch marks. Such details find visual form in intensely crowded compositions of witches' kitchens showing preparations for the sabbath [69], or wild landscapes, such as the clouds of polluted smoke depicted in a widely-distributed print after a design by Jacques de Gheyn [30].

This print influenced Salvator Rosa's demonological paintings, which reflected a fascination with theatrical matters, the classical past and the thrill of the occult. The proto-Romantic Italian painter, poet and actor Rosa seems to have known the Latin poem *The Civil War* (c.61 AD), by the Roman poet Lucan, with its ghastly images of the Thessalian witch Erichtho:

she gleefully digs out the cold eyeballs and gnaws the pallid nails on withered hands.

Scenes of witchcraft were not necessarily horrifying but could reflect an enjoyment of the satirical and fantastic, especially in France and Italy. These burlesque works represented the spirit of doubt and scepticism explored by some writers throughout the darkest years of the witch-craze and the need to challenge religious fanaticism with humour and lightness of touch. The same enjoyment of eerie thrills inspired masques or theatrical performances with political and historical resonance in Elizabethan and Jacobean England and Enlightenment Spain.

Johann Wolfgang von Goethe's *Faust*, based on the mediaeval German legend that had inspired Christopher Marlowe's *Doctor Faustus*, was immediately illustrated by artists after the publication of Part 1 in 1808. His descriptions of Faust and Mephistopheles joining a witches' sabbath on *Walpurgisnacht* (30 April to 1 May) were as attractive to illustrators as the young witch pursuing the drunken Tam in Robert Burns's poem *Tam o' Shanter* (1791).

30 AFTER JACQUES DE GHEYN II
(1565–1629);
ENGRAVED BY ANDRIES JACOBSZ
STOCK (1580–c.1648)

Preparation for the Witches' Sabbath,
c.1610

Engraving printed from two plates, 43.7 × 65.4 cm
Ashmolean Museum, Oxford

De Gheyn was himself a brilliant printmaker, but this extremely influential print is engraved in reverse by Stock after a drawing by de Gheyn in the Staatsgalerie Stuttgart. The composition, based on a series of huge curves and thick billowing smoke, was copied by many others. A motif which attracted particular attention was that of the fat witch in the foreground, stirring a cauldron between her legs with a huge thigh bone while reading from a book of spells. The gesticulating pose of the bony, bare-breasted hag was also appropriated by other artists, as were the bare-breasted or bare-bottomed witches flying on broomsticks or chimeric creatures. The parabolic curves of wild explosions from a square-topped volcano behind the central group, which relates witchcraft to frightening natural events such as earthquakes, also found imitators and de Gheyn himself has borrowed the earth-bound witch in a dark cave next to the steaming cauldron from Pieter Bruegel the Elder. The intense image also contains a large miserable cupid riding a winged dragon, while salamanders and dragons emerge from the earth where dead bodies are partially revealed. A witch draws water from a well to the right of the blasted tree, but this wild landscape image is very far from the ghoulish domesticity of witches' kitchens as depicted by artists from the southern Netherlands.

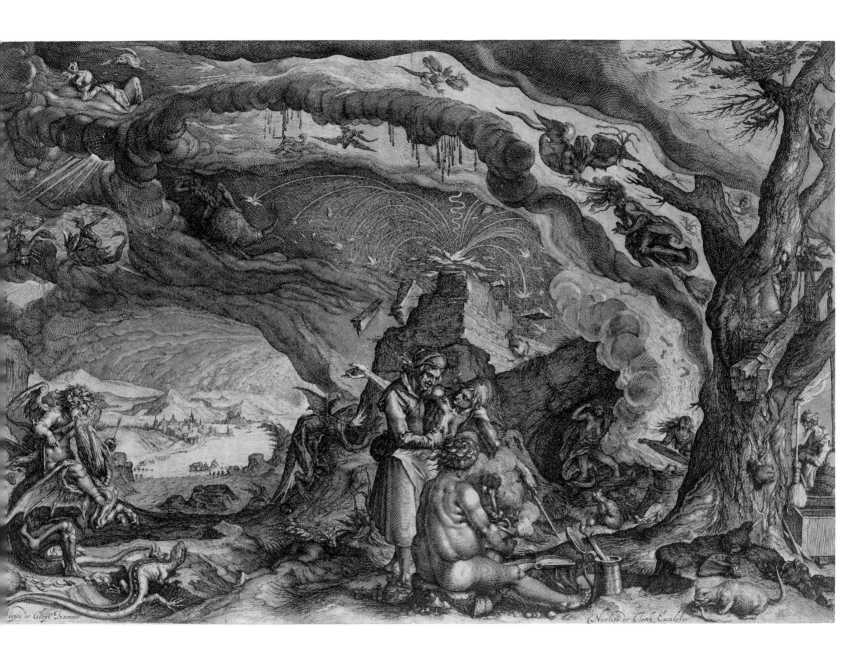

Figes de Gheyn Inventor. Nicolaes de Clerck Excudebat.

31 JACQUES DE GHEYN II
(1565–1629)

Witches in a Cellar, 1604

Pen and brush with brown and grey ink,
28.2 × 41 cm
Ashmolean Museum, Oxford

De Gheyn returned to the subject of witches and black magic again and again in powerfully disturbing drawings. Born in Antwerp, he moved to Leiden, with its newly established Protestant university, in 1595. He associated with the pioneering scholars of the new empirical sciences of natural history, anatomy, astronomy and geography, and was closely associated with the eminent thinkers and politicians of his day. De Gheyn's own detailed watercolours of natural history objects are counterbalanced by wild inventions of occult practices, with the faces of witches borrowed from his observational pen and ink drawings of itinerant gypsies. The scene depicted in this spooky wash drawing takes place within a vaulted cellar (employed by many Netherlandish artists to signify the occult underworld); the seated witch with cat and gesticulating attendant is busy fashioning a wax manikin. Like the third hag reading a book of spells these figures ignore the fetid clutter of dismembered cadavers, heads, rats and magic potions. The skeletal head of a horse demon on the left introduces the visual cannibalisation later employed by Rosa and others who assembled devilish 'monsters' from body parts, inspired by anatomical manuals. Broomsticks, smoke and cast shadows complete the repertoire of horror imagery.

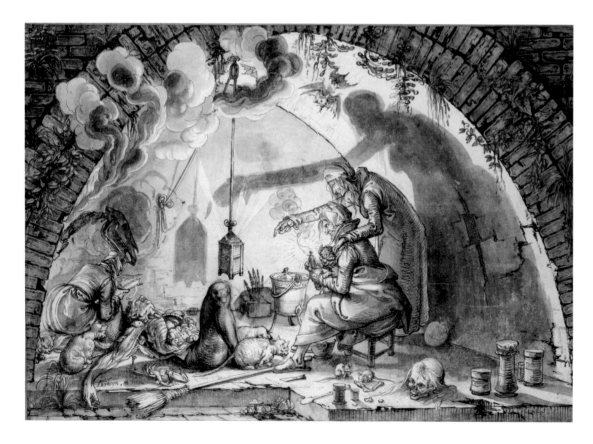

32 JACQUES DE GHEYN II (1565–1629)

A Witches' Sabbath, c.1600

Pen and brown ink and grey wash, with white heightening, on buff paper, 37.7 × 51.9 cm
Christ Church College, University of Oxford

The impressive size of this drawing (cut into two sections but rejoined in 1969) is matched by its unusual subject matter. The two witches on the left sit on a terrace outside a ghostly and abandoned mansion. One hag stirs a potion in a small cauldron, which is seething and smoking on her lap without the aid of a fire, while her cloaked skeletal companion looks balefully outwards. Another witch sleeps within a vaulted space to the rear, and an indeterminate figure haunts the ground floor. The scene is clearly not a sabbath but an evocation of an evil place in the countryside. The embracing couple on the extraordinary creature on the right are intended to evoke all the horror of an 'unnatural' coupling: that of an ancient hag with a younger man. Their lechery is underlined by de Gheyn's reversal of the traditional Western convention of intertwined legs to indicate the sexual act. In erotic graphics of the sixteenth century the courtesan has one leg over her male lover: here he inserts his leg between the skinny pins of the larger hag. Their demon-mount, imaginatively assembled from anatomical fragments, appears to read from the *grimoires* on the ground.

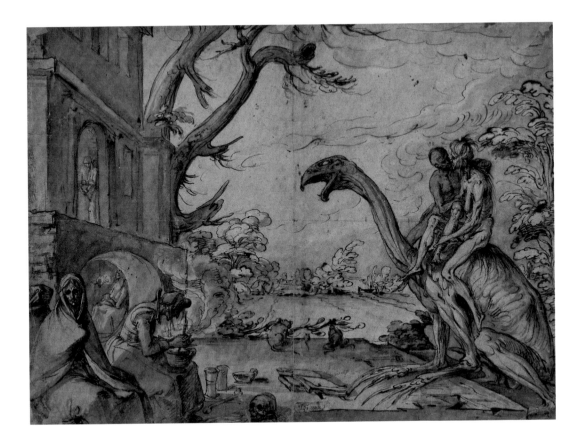

33 SALVATOR ROSA (1615–1673)

Witches at their Incantations (*Scene of Witchcraft*), c.1646

Oil on canvas, 72.5 × 132.5 cm
National Gallery, London

This is the most important of a small group of pictures inspired by the taste for witchcraft and the occult, which was especially strong in Florence, where Rosa lived during the 1640s.

In this stage-like composition, the central seated witch with a long bone in one hand is squeezing the blood from a human organ into a cauldron, held between her legs in the manner of de Gheyn's print. Nearby is a magical diagram pinned to the ground, while the other dramatically lit nude witches concentrate on a wax manikin being reflected in a mirror. Behind, one witch clips the toenails from a hanged corpse, while another, hair flying, fumigates it with a flaming pot. Two men hold a skeleton's hand to write some ghostly document, while above them looms a mysterious veiled figure wearing a wreath and carrying a ring of candles, and a half-naked hag points a blindfolded initiate towards the cadaver. To the right of the tree, a knight in armour sets fire to a document while being beaten by a figure receiving a bloody heart on the end of a sword, offered by a bearded figure in oriental robes. An old witch holds up a swaddled infant as a sacrificial victim. The skeletal monster in the background is derived from a manual of animal anatomy illustrated by Filippo Napoletano (*c.*1587–1629).

34 PAULA REGO (B.1935)

Witches at their Incantations after Salvator Rosa, 1991

Etching and aquatint, 57 × 75 cm
National Gallery, London

Paula Rego drew directly from Rosa's *Incantations* when she was Associate Artist at the National Gallery, London from 1989 to 1990. This print was issued in a special portfolio. The image as etched on the printing plate by Rego would have been the same way round as the painting but is printed in reverse. This is an accurate copy of Rosa's famous work, but because it is monochrome and strongly linear, with the white of the paper representing the painted flesh tints, it loses the drama and mystery of the original. Instead she exposes the sly humour that we do not necessarily notice in Rosa, especially the ridiculous bending skeletal figure in armour and a creature with a long proboscis advancing in the foreground. Rego has altered the dimensions of *Incantations* where the elongated frieze-like format contributed to the frozen meticulousness of the work. The change of proportion allows the skeletal bird demon to dominate the composition and gives us a clear view of the felon's corpse hanging from the blasted tree. Rego has become increasingly concerned with caustic and discomforting satire and social commentary in her practice, so her attraction to Rosa is very revealing.

35 JEAN (JAN) ZIARNKO, (c.1575–c.1629)

Description et figure du sabbat, centrefold in Pierre de Lancre's (1553–1631) *On the Inconstancy of Witches* (*Tableau de l'inconstance des mauvais anges et demons*), second edition, Paris, 1613, Nicolas Buon

Engraving, 25.1 × 32 cm
Special Collections, University of Glasgow Library

36 AFTER MICHAEL HERR (OR HEER) (1591–1661); ETCHED BY MATTHAEUS MERIAN THE ELDER (1593–1650)

Zauberey, or Sabbath on the Blocksberg, 1626

Broadside with Latin text by Johann Ludwig Gottfried (seventeenth century) plus anonymous German verses, 28.2 × 32.5 cm
British Museum, London

The smoke from a central cauldron tended by clothed witches rises in an apocalyptic pillar of pollution to fill the entire height of the image, similar to the print after de Gheyn's from which the flying witches are crudely copied. To the right, Satan in the form of a he-goat with five horns, with the central one alight, is enthroned between the Queen of the Coven and a nun, while a naked witch and winged demon present a stolen child for cannibalisation. Elsewhere, child 'converts' tend a flock of toads in a swamp, witches partake of a banquet of dead bodies or engage in nude dancing. Such a lewd dance was described by Ben Jonson in his *Masque of Queens* (1609): 'all things contrary to the custom of men, dancing, back to back, hip to hip, their hands joined, making their circles backward'. The activities are observed by a group of grandly dressed and masked witnesses, and sections of the image are keyed alphabetically below.

This crowded and popular broadsheet draws on the illustration depicting a witches' sabbath in de Lancre's book *On the Inconstancy of Witches* [35], that was in turn derived from de Gheyn's influential *Sabbath* print. It indicates how easily images moved from learned treatises into the public realm at this time, and were borrowed by artists and playwrights from different countries, or embroidered with additional details in the restaging. In the foreground witches are engaged in a drunken and drugged orgy with devils while the group on the right, about to have a sabbath feast, have brought along a sack of decomposing cadavers and dead babies. On the left of the huge spume of smoke from the central cauldron, in which male witches also fly, a long queue snakes down from the hill in order to kiss the Devil's backside. A magic incantation by a male necromancer takes place on the right in mysterious classical ruins, filled with demon participants. The pregnant witch standing by the cauldron recalls a learned debate about whether devils or *incubi* (male demons), could impregnate women.

DESCRIPTION ET FIGVRE DV SABBAT DES SORCIERS.

Il faut mettre cette Figure au Discours 4. du 2. Liure, entre les pages 118. & 119.

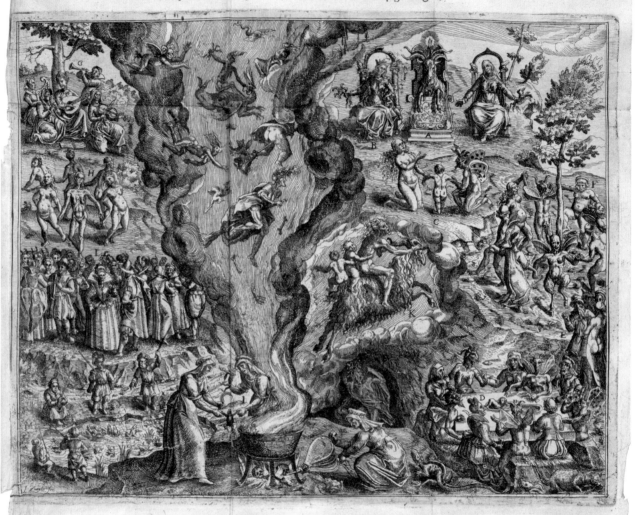

A Satan est dans vne Chaire dorée en forme de Bouc, qui presche auec cinq cornes, ayant la cinquiesme allumée pour allumer toutes les chandelles & feux du Sabbat.

B La Roine du Sabbat couronnée à dextre, & vne moins fauorie à senestre.

C Au dessous de sa chaire, est vne Sorciere qui luy presente vn enfant qu'elle a seduit.

D Voila les Conuiues de l'assemblée, ayant chacune vn Demon pres d'elle : Et en ce festin, ne se sert autre viande, que charoignes, chair de pendus, cœurs d'enfans non baptisez, & autres animaux immondes, du tout hors du commerce & vsage des Chrestiens, le tout incipide & sans sel.

E En ce festin ne sont admis, ces spectateurs, qui sont plusieurs poures Sorcieres reiettees aux recoings, & qui n'osent s'approcher des grandes ceremonies.

F Apres la pance vient la danse : car apres auoir esté repeus de viandes, ou fugitiues, ou illusoires, ou tres-pernicieuses & abominables ; chaque Demon meine celle qui estoit pres de luy à table, au dessous de cet arbre maudit, & là le premier ayant le visage tourné vers le rond de la danse, & le second en dehors, & les autres ainsi ensuiuant tout de mesme, ils dansent, trepignent & tripudient, auec les plus indecens & sales mouuemens qu'ils peuuent.

G Ce sont les ioüeurs d'instrumens, & le concert de Musique, au chant & harmonie de laquelle ils dansent & sautent.

H Au dessous se void vne troupe de femmes & filles qui dansent toutes le visage en dehors le rond de la danse.

I Voila la Chaudiere sur le feu pour faire toute sorte de poison, soit pour faire mourir & maleficier les hommes, soit pour gaster le bestail ; l'vne tient les serpens & crapaux en main, & l'autre leur couppe la teste, & les escorche, puis les iette dans la chaudiere.

K Pendant cet entretien plusieurs Sorcieres arriuent au Sabbat sur des bastons & balais, d'autres sur des Boucs accompagnees des enfans qu'elles ont enleué & suborné, lesquels elles viennent offrir à Satan : D'autres partant du Sabbat, & transportees en l'air, s'en vont sur la mer ou ailleurs exciter des orages & tempestes.

L Ce sont les grands Seigneurs & Dames, & autres gens riches & puissans, qui traictent les grands affaires du Sabbat, où ils paroissent voilez, & les femmes auec des masques, pour se tenir tousiours à couuert & incogneus.

M Pres de ce ruisseau sont les petits enfans, lesquels auec des verges & houssines blanches, esloignez des ceremonies, gardent chacun les troupeaux des crapaux de celles qui ont accoustumé les mener au Sabbat.

Outre ce, il y a plusieurs autres choses que la petitesse de ceste figure n'a peu souffrir, qui se pourront entendre commodément par le Discours du Sabbat, qui est au Discours 4. du Liure second.

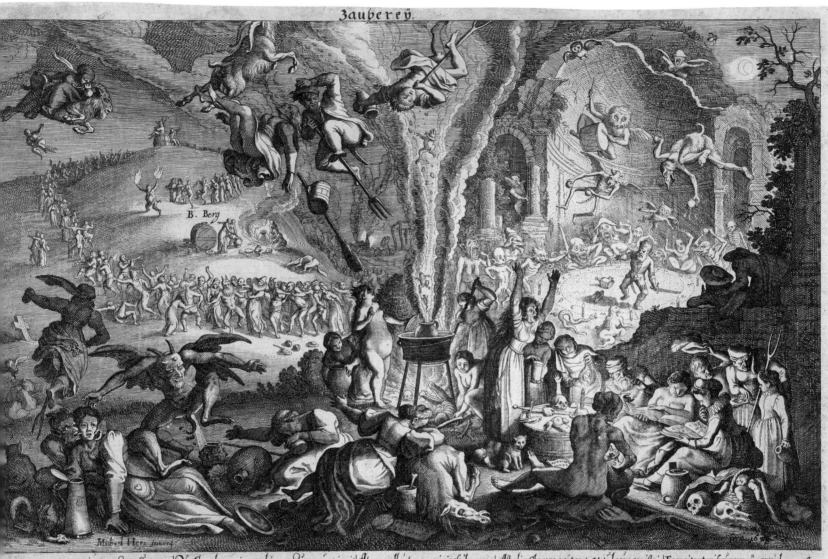

onomænomenium cupiens spectare furores, | Quæ Cacodæmoniam rabiem nocturnaque pingit | Atæ per albentes pecuinis ossib. agros. | Ast aliæ Choreas agitant, Vetulæque canistris | Exagitant miserum varijs speciei, agrestem
itis metuenda nigri lustrare Theatra: | Gaudia, conuent, Stijgios, fœdosque hymenæos | Hic sircis, ille vectantur olentib. hircis | Expediunt puerorium art, semes aqq membra. | Quo ruitis miseri, quos tanta cupido Gehennæ
ades, hancque vide spectator amice, tabellam, | Cum Sathana per busta modis squallentia miris, | Ad sedum, Regina coquit lethale venenu. | Hic Furiæ Lamiæq volant, et spectra tremenda. | Et desiderium flama cruciabilis urget.

167.

I.L.G.

SEh an O Leser dieses Bild/
So schröcklich/seltzam/wüst vñ wild
Darinn vor Augen wird gestellt/
Der gröste Jammer in der Welt/
Wie sich die rasend Teufflisch Rott/
Nach dem sie hat verleugnet Gott/
Vnd sich ergeben dem Sathan/
Zusammen fügt auff diesem Plan/
Bey finsterer Nächtlicher Zeit
Allda sucht ein Elende Freud/
Im freyen Feld/ an ödem Ort/
In Forcht vnd Schrecken hie vnd dort.

Da der toll/blind vnd thöricht Hauff/
Dem Teuffel sich selbst opffert auff/
Der doch so schröcklich ihn erscheint/
Daß wer es sicht vor Jammer weint.
Ist doch kein Fabel noch Gedicht/
Sondern ein warhafftig Geschicht/
Der Leut die solches han gesehen/
Wie auch deß Orts da es geschehen
Man Ehrenthalb verschonen mag/
Es kompt doch noch an den Tag.
Dann es helt diese Schelmenzunfft/
Auch anderstwo Zusammenkunfft/

Wie man solches erfehrt vnd liest/
Daß daran nicht zu zwoiffeln ist.
Etlich auff Gabeln in die Lufft/
Fahrn über hohe Berg vnd Klufft/
Andere werden vom Bock verzuckt
An diesen schnöden Ort verruckt/
Da sie pflegen deß Sathans Lieb/
Auß seinem bösen zwang vnd trieb/
Daß es zu hören schröcklich ist/
Wann ein Mensch sein so gar vergifst/
Sie tantzen/springen/schreyen/rasen
Vntern Galgen auff dem Schindwasen/

Dann wie da ist die Galliard/
So hat auch der Tanckplatz sein Art/
Der Sathan hie Platzmeister ist/
Dem folgt der gantze Hauff zur frist/
Biß er sie in die Höll hinein
Bringt vnd führt in die Ewig Pein.
Hie sicht man alte Weiber stahn/
Die tod Kinder in Körben han/
Mißbrauchen vnzeitig Geburt.
Ein andre mit dem Teuffel huhrt/
Die dritte frißt vnd säufft sich voll/
Wird von Höllischem Tranck gantz toll.

Auch finden sich Männer herbey/
Damit der Reyhen nur gantz sey/
Die Königin das Gifft bereit/
Der Bawr im Circkel ist wol geheut
Vom Gspenst so mancherley Gesicht/
Er kan sich bald erwehren nicht.
Ins gmein lehrt man da Zauberey/
All Laster Schand vnd Schelmerey/
O daß der Mensch so gar verrucht/
Mit Macht seine Verdamnuß sucht/
Vnd eylt mit vollem Sporen streich/
Ins Höllisch Fewer vnd Teuffels Reich/

37 AFTER DAVID TENIERS
THE YOUNGER (1610–1690);
ETCHED BY JEAN JACQUES
ALIAMET (1726–1788)

Departure for the Sabbath, 1755

Etching, 37.8 × 27.3 cm
Ashmolean Museum, Oxford

This is a print after a painting created in the previous century, versions of which are in various collections. The witch kneeling in front of the fire with a book of charms in her hand is rubbing flying ointment into the body of the naked witch standing with a broomstick between her legs, who is about to fly up the chimney to attend a witches' sabbath. The naked bottom and cloven hoofs of some creature which has already gone ahead of her are visible above the burning fire, while the demons in this sinister witches' kitchen include a horrible flying fish demon, or *serra*, which occurs so often in fantasies inspired by the Bruegel family, and is ultimately derived from Hieronymus Bosch. The ugly old hag at the table with her mortar and pestle and phials, being attended by a devil that could have been imagined by Dürer, shows incipient horns beneath her cap. She looks towards a collection of objects including a skull, hourglass, knife, herbs and playing cards that will be used to summon spirits for some other nefarious deeds. There is a lighted 'hand of glory' (the hand from a hanged felon or dead child, when lit served as a lamp) on the chimney shelf.

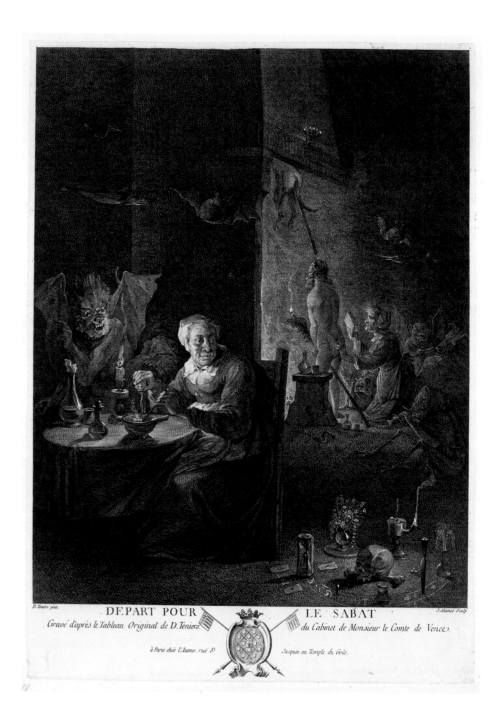

38 AFTER DAVID TENIERS
THE YOUNGER (1610–1690);
ETCHED BY JEAN JACQUES
ALIAMET (1726–1788)

Arrival at the Sabbath, 1755

Etching, 38.3 × 28.1 cm
British Museum, London

This late print by Aliamet is based on a
fragment of a painting by Teniers depicting
a central gallows (here represented as a
broken post) beneath which a witch is
digging around the feet of a hanged corpse,
as she searches for mandrake roots.

Mandrakes, which according to legend,
omit a shriek when pulled from the ground
and resemble demonic creatures, were
believed to grow below gallows-trees, as
they were generated from the emissions
of hanged men. Many works from
Teniers's enormous oeuvre are now only
known from engravings by Aliamet, who
also appears to have exercised his own
imagination in this dark work where
the corpse is no longer present. A group
of monsters and little people attend the
graveyard exhumation, lit by a witch with a
torch and the huge lantern. A small horned
devil, who often attends on Saint Anthony
in Teniers's paintings, plays a stringed
instrument for this ghoulish gathering.

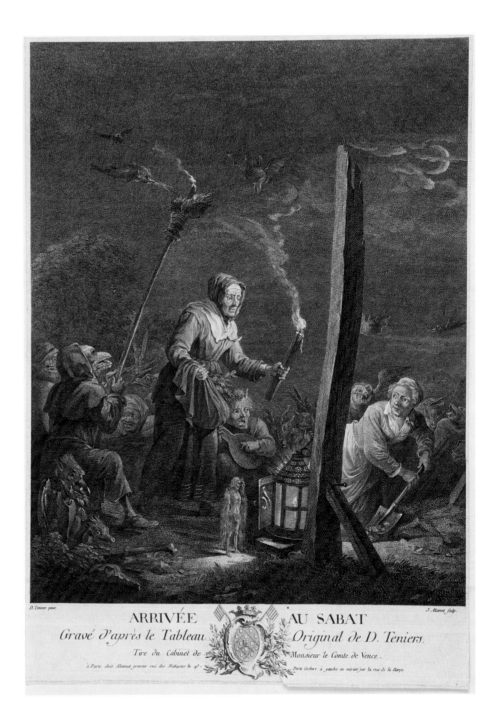

39 CLAUDE GILLOT (1673–1722);
FINISHED BY JEAN AUDRAN
(1667–1756) AFTER GILLOT'S DEATH

Les Sabbats (*Witches' Sabbaths*) I
(1698–1722)

One of a pair of etchings, text in margin, '*Errant
pendant la nuit…*' (Wandering in a lonely place at
night…), 23.9 × 32.5 cm
British Museum, London

Although he gained official recognition
by being made a member of the Académie
Royale, Paris in 1715, Claude Gillot was
mainly known as a decorative artist,
designing tapestry cartoons, book illustra-
tions and sets and costumes for the opera.

Many of his drawings and etchings are
related to humorous or satirical scenes
from the Italian *commedia dell'arte*, whose
players were banished from Paris between
1697 and 1716. He was profoundly
influenced by the mannerist prints of
Jacques Callot (*c.*1592/3–1635) whose
bizarre and good-humoured fantasies
had such an influence in Italy where he
resided for many years. Gillot etched most
of his own drawings of slender, weightless
figures with small heads and tapering arms
and legs. Other artists also engraved his
work but never quite caught the unique

qualities of his nervous, hovering line. The
lightness of Gillot's invention has turned
these paired scenes of witchcraft into
rococo fantasies, with horror dispelled
and scenes of torture transformed into
decorative tropes.

Gillot developed the new genre of *fêtes
galantes*, poetic/melancholy scenes of
courtly amusement in landscape settings,
employed by his more famous pupil-assist-
ants Jean-Antoine Watteau (1684–1721)
and Nicolas Lancret (1690–1743).

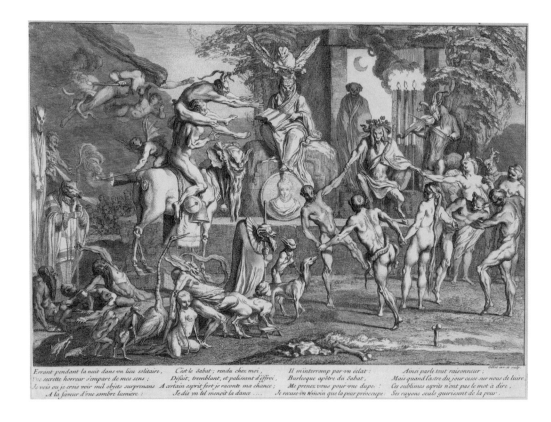

Errant pendant la nuit dans vn lieu solitaire, C'est le Sabat ; rendu chez moi , Il m'interromp par vn eclat : Ainsi parle tout raisonneur ;
Vne secrette horreur s'empare de mes sens ; Défait, tremblant, et palissant d'effroi , Burlesque apôtre du Sabat , Mais quand l'astre du jour cesse sur nous de luire,
Je vois ou je crois voir mil objets surprenans A certain esprit fort, je raconte ma chance ; Me prenez vous pour vne dupe . Ces sublimes esprits n'ont pas le mot à dire ,
A la faveur d'vne sombre lumiere : Je dis vn tel mensongit la dance …. Je recuse vn témoin que la peur préoccupe Ses rayons seuls guerissent de la peur .

40 CLAUDE GILLOT (1673–1722)

Les Sabbats (*Witches' Sabbaths*) II
(1698–1722)

One of a pair of etchings, text in margin, '*Est-ce un enchantement ...*' (Is this magic or illusion...),
24 × 32.2 cm
British Museum, London

The texts below the prints indicate that these scenes of 'enchantment and illusion' are burlesques, arising from the sophisticated French tradition of the farcical novel *The History of the Ridiculous Extravagancies of Monsieur Oufle* (1710) by Laurent Bordelon. Gillot's garlanded goat devil at the centre of the witches' dance in the night sabbath is very similar to that found in Goya's later *El Aquelarre* (*The Witches' Sabbath*), 1797, painted for the Duchess of Osuna. The wrestling demon with crooked horns perched on the shoulders of another also appears in Goya, as does the harpy figure. A necromancer is at the centre of the print, while a horned devil in this print supervises a turning spit from which two suspended bodies are being slowly roasted to the great enjoyment of a motley crew of onlookers. This is a reversal of the *autos-da-fé* (tests of faith) of the Spanish Inquisition where the 'innocent' burned wicked sorcerers. Two ridiculous witches share a long broomstick with a collapsed putto; the back figure is propelling them along by dipping one foot in the air current.

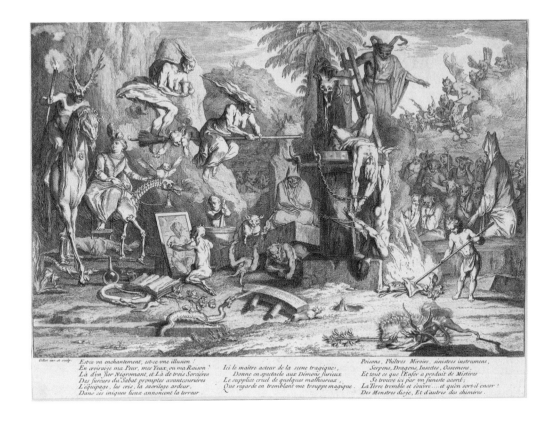

41 VITTORIO MARIA BIGARI
(1692–1776)

A Witches' Sabbath

Brush drawing in brown wash heightened
with white, on grey-brown prepared paper,
28.8 × 40.5 cm
British Museum, London

The attribution of this fine drawing to
the Bolognese artist Bigari by the artist
William Young Ottley (1771–1836), an
early Keeper of Prints and Drawings
at the British Museum, has never been
questioned. However, its use of brown wash,
with strengthened areas over lighter brush
under-painting, is very similar to that found
in a brown wash drawing of *commedia dell'arte*
figures perched on high chairs by Gillot in
the Art Institute of Chicago. The central fea-
ture of the rotating spit for roasting hanging
innocents (including a child) is directly
borrowed from Gillot's *Is this Magic…* [40]
print, although now two nude witches are
pushing the turning gear while another naked
hag tends the fire. The skeleton-headed and
hooded seated figure is also borrowed directly
from the print, as is the book of spells above
an ouroboros (snake with its tail in its mouth)
and a sprig of dried herbs used for making
spells. A necromancer rather than a horned
devil has climbed the ladder to manage the
spit and he waves a wand.

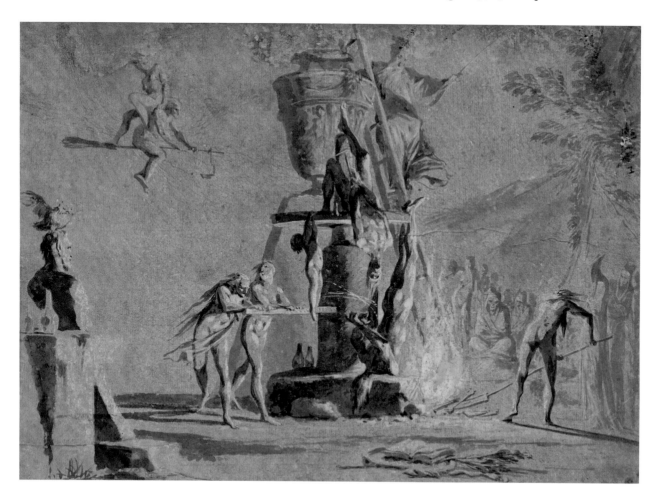

42 FRANCISCO DE GOYA
Y LUCIENTES (1746–1828)

A Scene from 'The Forcibly Bewitched',
1798

Oil on canvas, 42.5 × 30.8 cm
National Gallery, London

This represents a scene from *The Forcibly Bewitched* (*El hechizado por fuerza*) by the Spanish playwright Antonio de Zamora, which was staged regularly well into the nineteenth century. This painting was part of a series of six witch paintings by Goya that was bought by the Duke and Duchess of Osuna in 1799. They originally hung in the boudoir of the Duchess in their country villa, the Alameda, where theatrical events were staged for a liberal and diverse group of acquaintances. The painting reproduces what was considered the most comical moment in the play, when a miserly and superstitious cleric, Don Claudio, walks into the bedroom of a person supposed to be a witch. Believing that he will die once the oil in the lamp is consumed, he attempts to refill it holding his hand to his mouth either in terror or to prevent the Devil getting in. At the lower right is the partial inscription *lampara descomunal* (monstrous lamp) on an out-of-scale *grimoire*. This, together with the lit-up face of the cleric and the shadowy donkey demons beyond, situate this work as a scene in the theatre.

43 HENRY FUSELI (1741–1825)

The Witch and the Mandrake, c.1812

Graphite over red chalk, on fine waxed paper,
42.8 × 54.5 cm

Ashmolean Museum, Oxford

This preparatory drawing is for one of a
pair of etchings made by Fuseli in 1812,
illustrating the witches' song from Ben
Jonson's *Masque of Queens* (1609).

> *I last night lay all alone*
> *O' the ground to hear the mandrake groan;*
> *And plucked him up, though he grew*
> *full low,*
> *And as I had done, the cock did crow.*

The witch with her aquiline nose and jutting
jaw, and unseemly crouched position, is
wearing a hooded veil of the sort that also
appears in Fuseli's other witch paintings.
The mandrake root, resembling a human
figure that she is grasping or tickling with
one huge hand, is equally hooded with a
curious veil and vegetal top. It was believed
it would emit a ghastly shriek when dug
up and the companion work shows the
witch grubbing in the ground watched by
her horrified daughter. The broad forceful
strokes of the drawing anticipate the free
treatment of the etching. It relates to a
lost painting, probably exhibited at the
Royal Academy in London in 1785 with its
fellow work *The Mandrake: A Charm* (Yale
Center for British Art, New Haven). The
eighteenth-century writer and antiquarian
Horace Walpole described the painting as
'shockingly mad'.

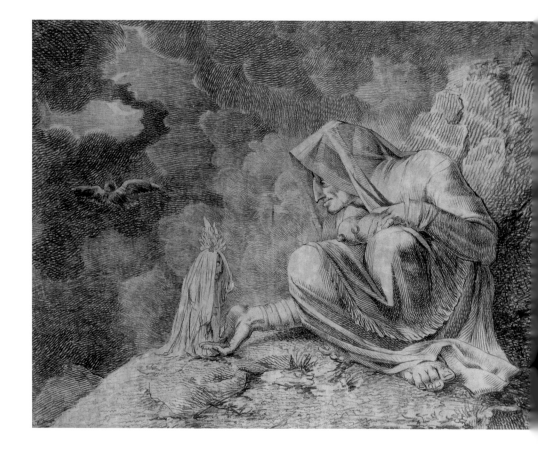

44 THEODOR VON HOLST
(1810–1844)

Fantasy Based on Goethe's 'Faust',
1834

Oil on canvas, 111.6 × 75.7 cm
Tate, London

Holst, born in London to Russian parents, was a schoolboy pupil of Fuseli.

The full title of this work is *Mephistopheles Holding a Goblet Leaps above a Cauldron before a Young Witch and Demonic Figures*. It combines various elements from von Holst's unfinished set of twelve engravings for *Faust* that for many years, like many of his erotic drawings, were erroneously believed to have been created by Fuseli. Von Holst's abandonment of the *Faust* engravings is thought to be due to the success of Eugène Delacroix's (1798–1863) popular series of lithographs of the subject created at the same time [46]. Holst continued to be fascinated by the subject and in this wild canvas, painted very quickly and loosely, a demonic, flame-headed Mephistopheles holds a goblet in his right hand and leaps over a huge steaming metal cauldron that is bubbling without the aid of a fire. Facially he bears a considerable resemblance to Delacroix's Mephistopheles. The young girl next to him is probably their victim Marguerite (known as Gretchen), seduced by Faust, who had slain her brother in a duel. She stands still amongst the turbulent crowd of unruly creatures with a fixed and distant stare.

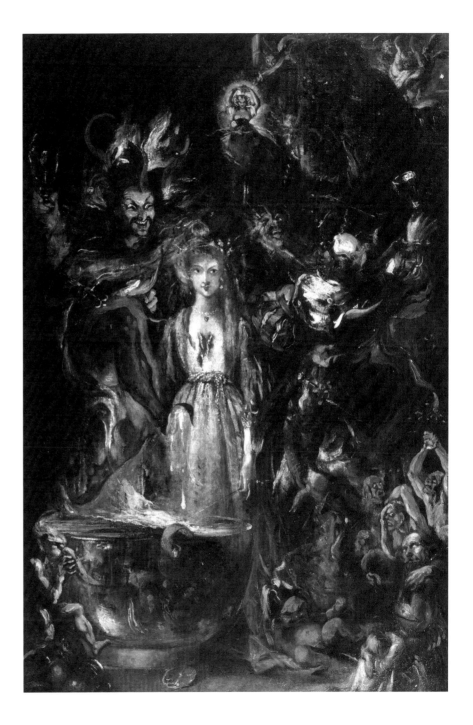

45 SIR JOSEPH NOEL PATON
(1821–1901)

Faust in the Witch's Kitchen, 1848
Pen and brown ink and wash over graphite,
24 × 29.9 cm (arched top to image)
Scottish National Gallery, Edinburgh

Paton was apprenticed as a textile
designer in Paisley, Scotland. He then
studied at the Royal Academy, London,
where he met John Everett Millais
(1829–1896) and associated with the Pre-
Raphaelite movement before returning
to Scotland where he became famous for
his 'fairy paintings'. The clarity of this
drawing was inspired by William Blake
and the outline designs of the German
artist Moritz Retzsch (1779–1857),
who also influenced Millais, William
Holman Hunt (1827–1910) and Dante
Gabriel Rossetti. Goethe himself had
admired Reztsch's illustrations for the
German edition of *Faust* (1816). Paton
depicts Mephistopheles ('Squire Satan')
reclining casually on a low settle playing
with a whisk. Faust, hand to brow, is
struck with admiration for the image of
the 'loveliest of women' (Helen of Troy)
conjured within a magic mirror. Details
of the witch's kitchen in the text are
depicted with great delight and accuracy,
such as the male and female apes that
have been left to tend the cauldron, and
the young monkey playing with a glass
globe just at the moment when the witch
comes down the chimney in a great flash
of light.

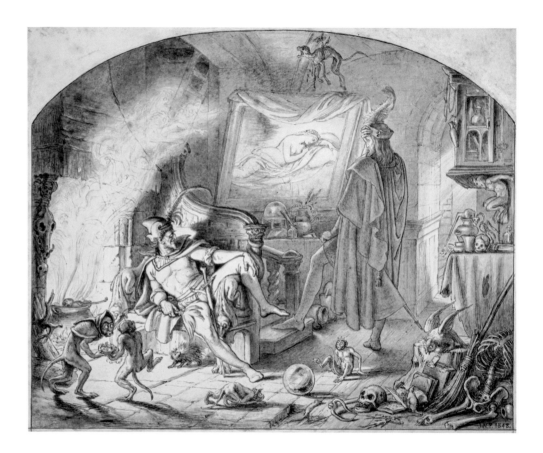

46 EUGÈNE DELACROIX
(1798–1863)

The Ghost of Marguerite Appearing to Faust, 1827

Lithograph, 22.6 × 35.3 cm
British Museum, London

The early illustrations to Goethe's *Faust* by the German artists Moritz Retzsch and Peter Cornelius (1783–1867) employed both fine and thick outlines with Neoclassical clarity. Cornelius, a member of the 'Nazarenes' in Rome, began his Faust drawings in 1810; his engravings were published later. Delacroix was probably referring to Cornelius when he wrote in his diary on 20 February 1821, 'Every time I look at the engravings of *Faust*, I am seized with a longing to employ an entirely new style of painting'. It was during Delacroix's visit to London in 1825 that he saw a 'diabolical' theatrical adaptation of Faust combining broad comedy and sinister effect, which inspired his seventeen *Faust* lithographs. This darkly romantic suite of prints employs curiously attenuated and mannered figures. In this print Faust and Mephistopheles have climbed the Brocken (Blocksberg) mountain on *Walpurgisnacht* and joined the witches in a sabbath dance. Faust sees the pale ghost of Marguerite with a bloody red band about her throat, although Mephistopheles assures him this is sorcery. Spooky pools of light reveal horrible serpents and nude twisted demons, while the observers are partially hidden behind a rock.

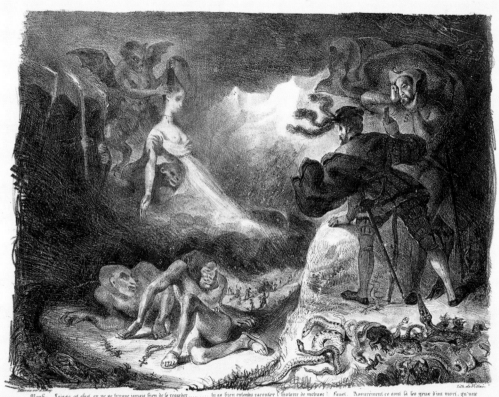

47 STEFANO ORLANDI (1681–1760)

*Architectural Fantasy with a Scene of
Sorcery* c.1730–40

Oil on canvas, 106.5 × 82 cm
Southampton City Art Gallery

The scale of the figures and the loose
quality of paint make details difficult
to read in this architectural fantasy,
now assigned to a Bolognese artist
who specialised in theatre scenery and
illusionistic decoration. On the steps,
partly in shadow in front of the warmly-lit
apsidal ended 'chapel' with its curiously
distorted perspective, a group of figures
engage in witchcraft. The central figure
with her bare breasts and dress caught back
to reveal her legs is reading from a *grimoire*,
while pointing with a wand towards a
cadaver laid out in swathing cloths, and is
attended by a witch who is cutting open its
stomach to reveal entrails. A figure on the
right is chaperoned by a dragon breathing
white fire, while the female figure in a red
cape on the other side holds what could
be a musical instrument, or vase, while
another figure rushes towards her with a
hand held up. A decapitated sheep in the
background is about to be sacrificed on the
flames of an altar. This is one of a pair of
paintings which were previously attributed
to Alessandro Magnasco (1667–1749),
known for his witchcraft fantasies.

48 JAMES GILES (1801–1870)

The Weird Wife o' Lang Stane Lea, 1830

Oil on canvas, 81.6 × 116.6 cm
Royal Scottish Academy, Edinburgh

Megalithic stone circles were often associated with myths of witchcraft, especially in the context of the early nineteenth-century passion for folklore. James Giles's depiction of a witch striding within the sacred precinct of the stone circle at Castle Fraser in Aberdeenshire celebrates this tradition, and the associated interest in the monuments of his native Scotland. 'Weird' is an archaic word for 'fate' or 'destiny', so the 'Weird Wife' is most probably a witch representing the spirit of place, and is not just a wayfarer in the romantic landscape. A raven is perched on one of the standing stones and the presence of a crescent moon adds to the occult symbolism. The oversized rabbit on the right, picked out in the dying daylight, detracts somewhat from the eerie mood of the scene.

49 JOHN FAED RSA (1819–1902)

Illustration to Tam o' Shanter
by Robert Burns (1759–1796)

Study for an engraving
Brush, dark brown wash and white heightening on
paper, 6.4 × 8.5cm
Scottish National Gallery, Edinburgh

50 AFTER JOHN FAED RSA
(1819–1902); ENGRAVED BY JAMES
STEPHENSON (1808–1886)

'And scarcely had he Maggie rallied'

from *Tam o' Shanter* by Robert Burns
(1759–1796), Plate 5, 15.8 × 20.4cm
Royal Scottish Academy, Edinburgh

Robert Burns's epic poem *Tam o'Shanter* (1790), describes how, after late market-day carousing at an inn, the drunken Tam returns homeward on his faithful horse Maggie. Forcing his steed to pass Alloway Kirk, he observes the amazing sight of witches and warlocks celebrating a wild sabbath dance to bagpipes played by Old Nick who takes the form of a dog. Open coffins, murderers' corpses and any number of vile objects lie around, including lawyers' tongues and priests' heads, 'stinking, vile in every neuk' as well as 'wither'd beldams…louping and flinging on a crummock'. Tam is drunk enough to call after the very young witch Nannie in her short skirt, 'Weel done, Cutty-sark' thereby causing all the spectres and witches to turn on him with unearthly screams. The atmospheric brown ink and wash drawing by Faed in the National Gallery of Scotland and the more stolid engraving by James Stephenson based on it, depict this dramatic moment in front of the lit church door: 'And scarcely had he Maggie rallied / When out the hellish legion sallied.' In the next scene the pursuing Nannie robs poor Maggie of her tail as she jumps a river to safety: witches cannot cross water.

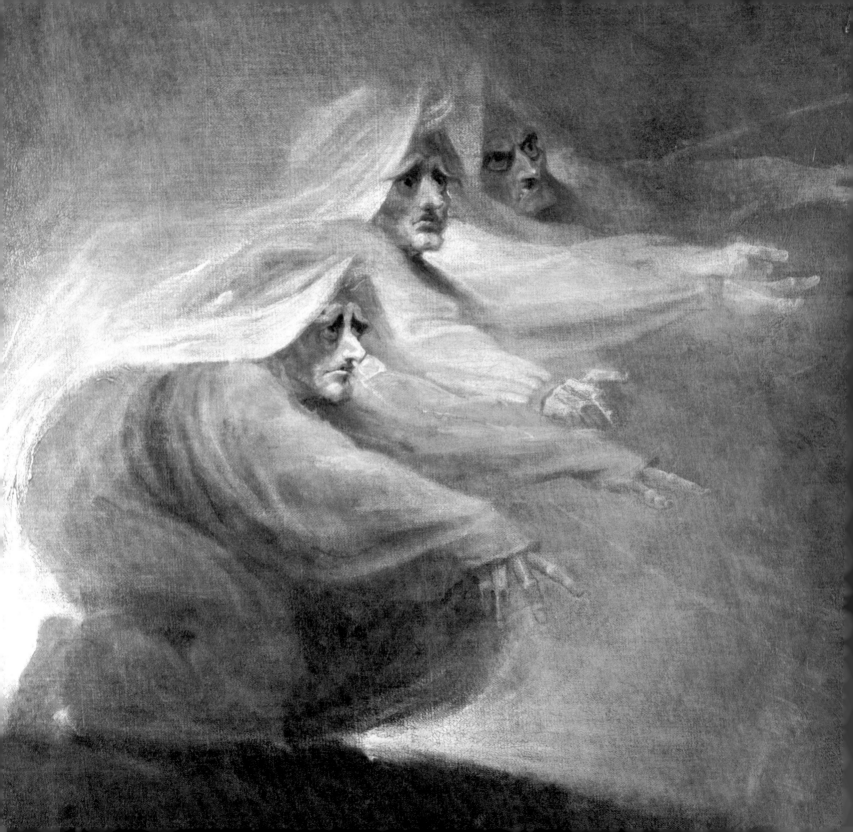

UNHOLY TRINITIES &
THE WEIRD SISTERS OF MACBETH

< Detail from [62]

The magical creatures of the Ancient World, both benign and terrifying, tend to come in triplicate: the three Graces, the three Fates, the Gorgons (one of whom, the snake-haired Medusa, was mortal), even the Norns of Northern mythology. Hecate, the ancient goddess of the crossroads stretching back to Babylonian and Homeric times, is sometimes three-bodied.

Hans Baldung Grien, a pupil of Dürer, casts a satirical eye on the classical *Three Fates*, 1513 [51], with Clotho spinning the thread of life, Atropos, an evil old crone, cutting it asunder, and Lachesis holding the gigantic distaff – figures that appear again in Goya's *Los Caprichos*. These figures can also be interpreted as perversions of the Christian idea of the Holy Trinity, just as black masses are a perversion of church sacraments and rites.

The three Weird Sisters of Shakespeare's *Macbeth* are the most theatrical of these evil and blasphemous trinities. Their chant at the beginning of the play about storms at sea would have resonated with those who knew that King James VI of Scotland nearly lost his life during a tempest while returning from Denmark. Agnes Sampson, head of a coven of Scottish witches, was burned after confessing to this crime and King James subsequently published his treatise *Daemonologie* (1597). The close interlinking between historical fact, political aspirations, judicial processes, superstition, religious belief and artistic invention is crucial to the shadowy field of witchcraft and its popular incorporation into Jacobean theatrical productions. There are few Shakespeare plays that do not contain some references to witchcraft.

Satan, Sin and Death form an infernal trinity in illustrations from Book 11 of John Milton's *Paradise Lost* (1667), where the hideous 'Snakie Sorceress', guardian of the gates of Hell and daughter of Satan, 'kennels the hounds of Hell within her snake belly' [60]. The subject was memorably painted by William Hogarth (1697–1764) in the late 1730s (Tate, London).

Fuseli, James Barry (1741–1806), Mortimer and George Romney (1734–1802) all explored dramatic witchcraft themes in the paintings they produced for Boydell's Shakespeare Gallery (opened 1789), either relating to Shakespeare or to Milton. The witch paintings produced for this project were popularised by their wide circulation in the form of mezzotints.

51 HANS BALDUNG GRIEN
(1484/5–1545)

The Three Fates, 1513

Woodcut, 21.8 × 15.1 cm
British Museum, London

Baldung represents the three Fates or *Moirai* in Greek as spinning, measuring and cutting the thread of life. The English term 'fairy' is derived from the Latin *fata* and the myth of three mysterious women who control human destiny appears in many cultures. Hesiod named the three avenging Fates to whom even the gods had to submit in his *Theogony*, and they were associated with birth, marriage and death in the Renaissance when they were sometimes conflated with Fortune and Chance. Clotho is the middle-aged matron spinning a thread with its spindle dangling from a very large distaff and she is very similar to the figure in Baldung's woodcut of *Phyllis Riding Aristotle*, 1513. The young grinning Lachesis measures the allotment of thread and the ancient Atropos cuts the thread with a large pair of shears. The inclusion of a small child in this image also relates it to Baldung's preoccupation with the Ages of Women, which he explored in paintings of the 1540s, but the fact that the figures are nude suggests that the three are witches. The moss dripping off the sinister overhanging branch of the tree suggests the landscape conventions more usually associated with the Danube school of printmakers, whereas the exaggerated length of the distaff stick and the expressions of the faces lend a slightly farcical air to this puzzling print.

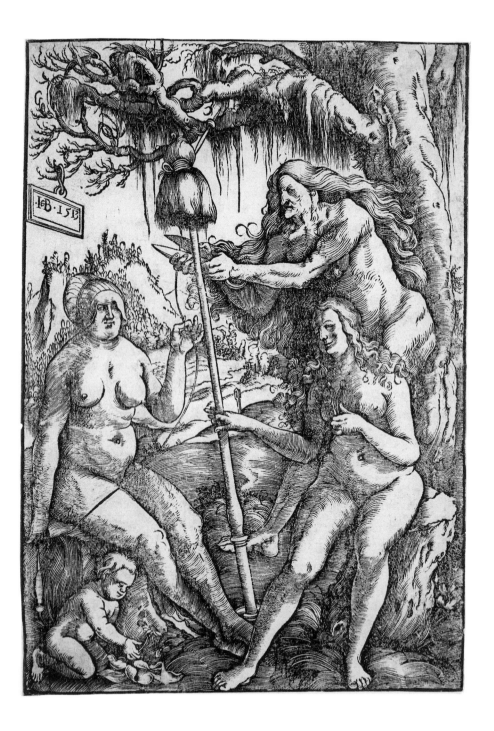

52 DANIEL HOPFER (c.1470–1536)

Gib Frid (Let Me Go), early 1500s

Etching, 22.5 × 15.7 cm
British Museum, London

Female scolds, chasing and beating
men and even riding on their backs
were the popular subjects of Northern
sixteenth-century prints, but three
hideous hags beating a scaly devil with
kitchen implements is rather unusual. The
horned demon with long dugs appears to
be giving birth to a hog that emerges from
between its legs, and a broken pitchfork
or oven fork in the foreground (which is
often ridden by witches in preference to a
besom broom) indicates that the scrawny
men-women are indeed witches. A coiled
tail appears from under the skirt of the
left-hand witch with one animal leg, her
hair streaming away from her shouting
head with huge chin and nose. The
demons climbing a tree and circling above
in the sky proclaim the occult nature of
this weird encounter. Hopfer, a supporter
of the Reformation and father of a family
of printmakers, was registered as a painter
and armourer in the city of Augsburg
in 1493, and he developed a technique
of etching on iron plates which allowed
for large editions. This etching is related
to a curious drawing of a man beating
a dragon (Kupferstichkabinett, Berlin)
previously attributed to Dürer and said to
come from Baldung's private collection.

53 FRANCISCO DE GOYA
Y LUCIENTES (1746–1828)

Hilan delgado (*They Spin Finely*), *Los Caprichos*, plate 44, 1799, trial proof

Etching, aquatint, drypoint and burin, 21.5 × 15 cm
British Museum, London

The three scrawny hags spinning thread in this monumental image are undoubtedly witches as well as the three Fates: signalled by the broomstick at the back, and the collection of dangling, dead infants, tied by threads on the right of the print. The dramatically lit witch in the foreground with her dark skirt and light flesh tones, twirling the thread between distaff and spindle, is the only one actually spinning, unlike an earlier grey wash drawing by Goya on a similar subject. That work of 1796–7, depicts three youthful inmates of the San Fernando hospice for vagrants with shaved heads and institutional uniforms, spinning thread. Its satirical readings revolve around wordplay with the terms *hilar* (to spin) and *hilado* (yarn), colloquial expressions for prostitution. The ancient profession of 'spinning' relates to the very long visual and literary association of witches with sexuality. Spinning, of course, has not always had such specific connotations: in earlier centuries the Virgin was sometimes pictured spinning thread while the Christ child sleeps.

44.

Hilan delgado.

54 THÉODULE-AUGUSTIN RIBOT
(1823–1891)

Three Witches around a Cauldron

Black chalk with stump on cream paper, drawn on
the back of an etching, 17.1 × 22.4 cm
British Museum, London

The intensity and placing on the page of
this drawing are not unrelated to Goya's
witches, unsurprising considering Ribot's
passionate interest in earlier Spanish
art. He studied the Spanish masters in
the short-lived Galerie Espagnole in the
Louvre established in 1838, which had
an enormous impact on French artists.
Although Ribot had little formal training,
he was a subtle and original draughtsman
and printmaker, as evidenced in this sketch
where the three malevolent witches around
the cauldron project an extraordinary
aura of concentration, cunning and sly
enjoyment. Ribot's particular 'touch'
and slightly tentative method of applying
charcoal are different from artists such as
Gustave Courbet (1819–1877) with his heavy
contours or the nervous lines of Honoré
Daumier (1808–1879) and Jean-François
Millet (1814–1875). Ribot, a successful
artist in his time, moved between gloomy
religious paintings and group portraits of
cooks, labourers, Breton fishermen and
Norman peasants with, very dark colours,
thick applications of paint and a great deal
of solemnity. The relative lightness of his
graphics and their off-beat compositions
reveal the more romantic aspects of this
often neglected artist.

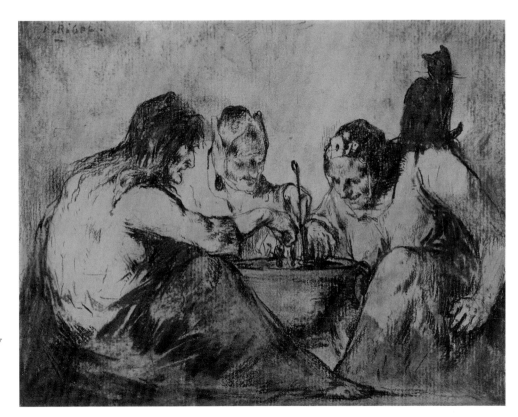

55 DANIEL GARDNER
(c.1750–1805)

*The Three Witches from Macbeth
(Elizabeth Lamb, Viscountess
Melbourne; Georgiana, Duchess of
Devonshire; Anne Seymour Damer),*
1775

Gouache and chalk, 94 × 79 cm
National Portrait Gallery, London

Gardner studied as a boy with George
Romney in Kendal, eventually moving
to London to the Royal Academy
Schools. He established a modest career
as a portraitist employing a mixture of
oil, gouache and pastel; Gainsborough
was also a great experimenter with
mixed techniques. This rare group
portrait in gouache and chalk is thought
to have been commissioned by Lady
Melbourne and there is a contemporary
reference to it in a society journal entry
of 1775 by Lady Mary Coke: '…instead
of *Finger of birth-strangled babe, etc.* their
cauldron is composed of roses and
carnations and I daresay they think
their charms more irresistible than
all the magick of the Witches'. 'Fancy
portraits' of the time often depicted
sitters in the guise of figures from the
classics, but the bold decision to show
these three well-known ladies as the
three notorious crones participating
in a play – although with no attempt
whatsoever to render them hideous, old
or evil – appears to illustrate a political
in-joke.

56 JOHN MICHAEL RYSBRACK
(1694–1770)

The Witches in Macbeth

Pen and brown ink, with brown wash, over red
chalk, heightened with white, 22.2 × 13.8 cm
British Museum, London

This is one of two similar drawings by
the Flemish-born sculptor who worked
in Britain from 1720 until his death,
carrying out important commissions
in Westminster Abbey. He was a noted
collector of prints and drawings as well as
being known for his own highly finished
drawings of classical and biblical subjects.
His two drawn versions of the three
witches from Macbeth approaching a
smoking cauldron on a stone altar employ
white highlights over brown wash and red
chalk. They are far more lively, sketchy and
impassioned than his usual more formal
drawings. Brandishing sticks, these rag-
gedy bare-breasted witches with uncouth
hair are like the *Three Witches* with torches
pictured in the publication by Vincenzo
Cartari, *Images of the Gods of the Ancients*
(1556), a source book for artists across
Europe as popular as the later Baroque
emblem books by Cesare Ripa, *Iconologia*
(1630). The related horizontal image of the
three witches was etched in reverse with
some mezzotint in 'imitation of a drawing'
by John Keyse Sherwin (1751–1790), about
1778, including three lines of text quoted
from *Macbeth*, Act IV, Scene i.

57 JOHN RUNCIMAN (1744–1768)

Three Heads: The Witches of Macbeth,
c.1767–8

Ink and body colour, on red-washed paper,
23.5 × 24.8 cm
Scottish National Gallery, Edinburgh

John Runciman, Alexander's [58] younger
brother, died of consumption in Italy only
a year after they both arrived to study in
Rome, where they joined the vibrant inter-
national group of artists associated with
Fuseli. The wonderful gestural freedom
of line in this assemblage of three hairless
heads with the pointed ears of Satyrs has
meant that for years this image was not
firmly associated with the three Weird
Sisters of *Macbeth*, although Runciman was
illustrating scenes from Shakespeare in
the 1760s. Although witch hags generally
have wild hair entwined with snakes, they
are often rather masculine in appearance,
or sexually indeterminate, particularly in
the case of Goya's representations. What
adds potency to this group is the skilful
suggestion of a cunning conspiracy being
'cooked up' by the evil trinity. Years later
Fuseli incorporated a group of five ghostly
heads within a halo of light on the left of
his painting *Percival Delivering Belisane from
the Enchantment of Urma* (Tate, London),
exhibited at the Royal Academy in London
in 1783 and based on a fictional tale
invented by Fuseli himself. These heads
seem to pay homage to Runciman's potent
work, although there is no evidence to
suggest that Fuseli knew this drawing.

58 ALEXANDER RUNCIMAN
(1736–1785)

The Witches Show Macbeth the Apparitions, c.1771–2

Pen and brown ink over graphite, 60.3 × 48 cm
Scottish National Gallery, Edinburgh

Runciman's unfinished drawing encompasses many modes from the well-conceived to the unfinished, the dramatically coherent to the experimental.

It illustrates Act IV, Scene i of *Macbeth*, the dramatic scene within 'A Dark Cave. In the middle, a boiling Cauldron', where the three witches name the awful ingredients for their 'hell-broth' before Macbeth enters. Light emanating from the bird-footed cauldron is indicated by leaving the creamy paper free of the hastily hatched pen textures of dark background, and by careful washes and dark accents in the frontal figures of Macbeth in armour and cloak and a dancing Hecate with one admonitory finger raised. Scottish-born Runciman, who spent time in Italy, was an etcher as well as painter, producing carefully finished prints. The mad, gesticulating skeletal figure in the background with steam issuing from her hair, exhibits the playfulness of a rough sketch. Of the apparitions summoned within the play, only the armed head is depicted, although the drama of stage lighting is suggested by agitated pen lines. The 'show of eight Kings' from the play is possibly indicated by a crowned skeletal figure on a horse; this is reminiscent of John Hamilton Mortimer's apocalyptic image, *Death on a Pale Horse*, c.1775.

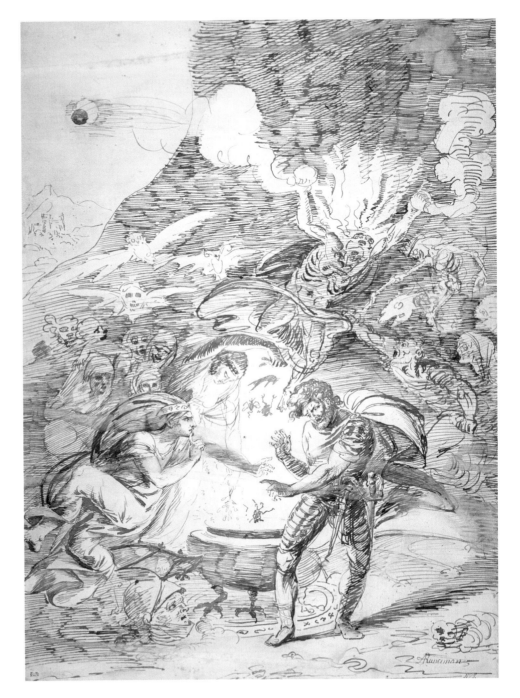

59 WILLIAM BLAKE (1757–1827)

The Night of Enitharmon's Joy
(formerly known as 'The Triple Hecate'),
c.1795

Coloured print with ink and watercolour, some
scraping and traces of pencil and charcoal, on
paper laid down on board, 41.6 × 56.1 cm
Scottish National Gallery, Edinburgh

There are three known impressions of this work (the other two are in Tate, London and the Huntington Library and Art Gallery, San Marino, California), printed from millboard instead of a conventional hard-wearing copper plate, and embellished with pen, ink and watercolour. Nowadays it is named after Blake's poem of 1794, *Europe*:

> *Now comes the night of Enitharmon's joy! …*
> *Go! tell the human race that Woman's love*
> *is Sin!*

Previously it was known as *The Triple Hecate* and assumed to relate to the appearance of the triple-bodied goddess of the crossroad in Shakespeare's *Macbeth*, probably twinned with the coloured print of the same date, *Pity*, as a naked newborn babe from Act 1, Scene vii of *Macbeth*. This was the interpretation supplied by John Ruskin (1819–1900), who described the composition as 'a wonderful witch with attendant owls'. In this interpretation the book under the hand of the triple figure is a *grimoire*, and the lewd donkey, lizard and owls represent the beasts of the underworld, the earth and the sky. The triple figure is situated at the intersection of contour lines, just as the ancient goddess, crowned with oak-leaves, guards the crossroads, 'the gathering place of the restless dead' in a lost play by Sophocles.

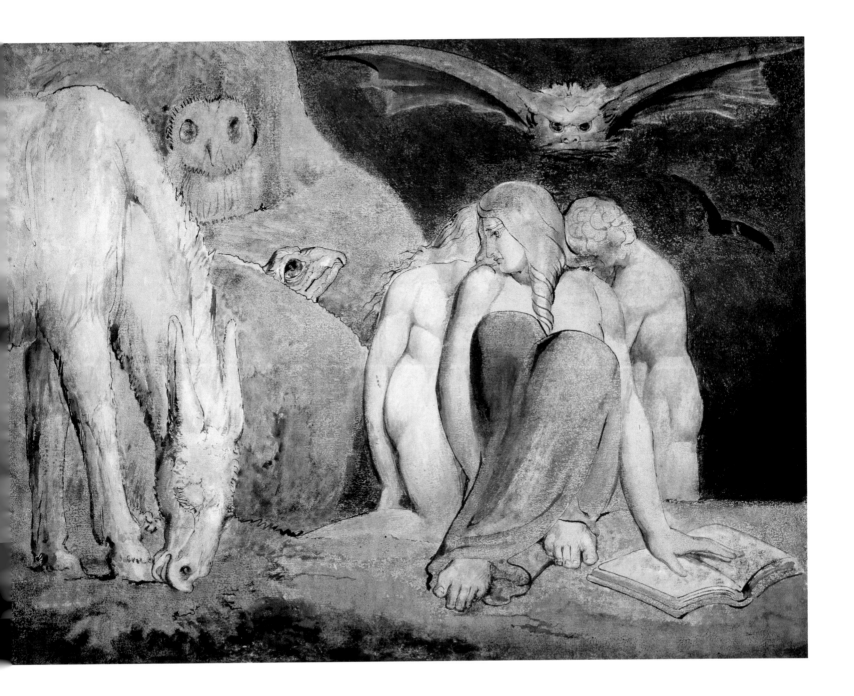

60 JAMES BARRY (1741–1806)

Satan, Sin and Death, c.1792–5

Etching, 56.8 × 51 cm
British Museum, London

This powerful etching, illustrating Book 11 of Milton's *Paradise Lost*, lines 666–72, relates to Barry's renewal of interest in Milton when at the peak of his activity as a printmaker. Barry was much influenced by his mentor, the Irish statesman and philosopher Edmund Burke's notions of the Sublime, and by artists such as Henry Fuseli, George Romney, William Blake and Alexander Runciman who also illustrated Milton's epic combination of the biblical and classical during this decade. The 'Infernal Trinity' of Barry's image departs slightly from Milton's text in depicting the moment when Satan, the grand fallen angel, descends to the portals of Hell to be confronted by Death and Sin. Sin attempts to intercede between Satan (her father) and Death (the fruit of their incestuous union) as they lift darts to strike each other. She is only human to the waist; below that she takes the form of a serpent. Girdled with the keys of hell, her womb contains the monstrous Hell Hounds engendered by her rape by Death:

> *… hourly born, with sorrow infinite*
> *To me, for when they list into the womb*
> *That bred them they return, and howl and gnaw*
> *My bowels, their repast …*

The jagged shading that defines these powerful figures and ties them into the gloomy background adds enormous drama and energy to this potent, noisy image.

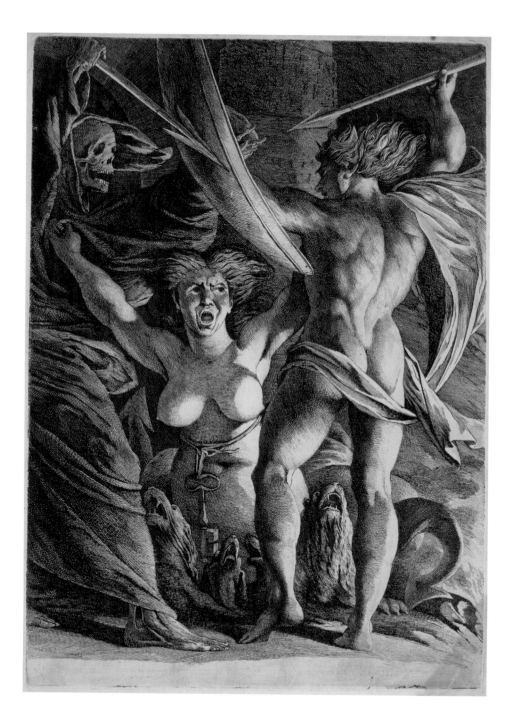

61 AFTER HENRY FUSELI (1741–1825);
MEZZOTINT BY JOHN RAPHAEL SMITH (1751–1812)

The Weird Sisters from Shakespeare's 'Macbeth', 1785

Mezzotint, 45.7 × 55.8 cm
British Museum, London

Fuseli painted and drew many versions of this powerfully simplified image depicting the moment in Act I, Scene iii when Macbeth first encounters the three witches on the heath, and Banquo exclaims:

> *So wither'd and so wild in their attire,*
> *That look not like th' inhabitants o' the earth*
> *… You seem to understand me,*
> *By each at once her choppy finger laying*
> *Upon her skinny lips: you should be women,*
> *And yet your beards forbid me to interpret*
> *That you are so.*

Long attracted to Shakespeare, Fuseli became a major contributor to and co-instigator of Boydell's Shakespeare Gallery set up in London in 1789, soon closed because of the disastrous effect of the French Revolution on the art market. Raphael Smith was one of the engravers employed to make prints after these original works for circulation, but many other printmakers also produced versions of this popular image. The exaggerated chins, noses and enveloping hoods became associated with theatrical witch imagery, and were picked up by caricaturists such as James Gillray (1756–1815) and Thomas Rowlandson (1756–1827).

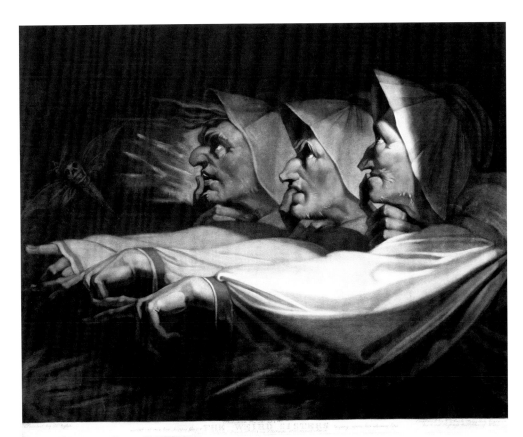

62 HENRY FUSELI (1741–1825)

Macbeth, Banquo and the Witches,
c.1793–4

Oil on canvas, 168 × 135 cm
Petworth House and Park, West Sussex
(National Trust)

Macbeth with his bloodied sword, and a
helmeted and armoured Banquo, almost
out of the frame, are the witnesses to the
three witches in this misty illustration of
Act I, Scene iii of *Macbeth*. It was one of
five works that Fuseli painted for James
Woodmason's Shakespeare Gallery, a
short-lived scheme initiated in Dublin in
1793 and intended to challenge Boydell's
Shakespeare Gallery in London. The
three ghostly witches, with their mas-
culine faces peering aggressively from
white hoods and draperies, have their
arms outstretched in the manner of the
earlier *Weird Sisters* [61]. However, they
are piled into an uneasy vertical grouping
above a mound, with the spectator also
looking upwards to a tall, dramatically
foreshortened Macbeth. His muscular
legs and buttocks, with a hint of a tartan
drape, tower above us. Below the hill
one can just discern the ghostly army
conjured by the witches, marching with
lances raised. In a smaller version/copy
of this painting, *c.*1800–10 (private
collection, USA) organised within a more
spacious horizontal format, the three
witches are grouped side by side and
Macbeth and Banquo watch in horror
within the frame.

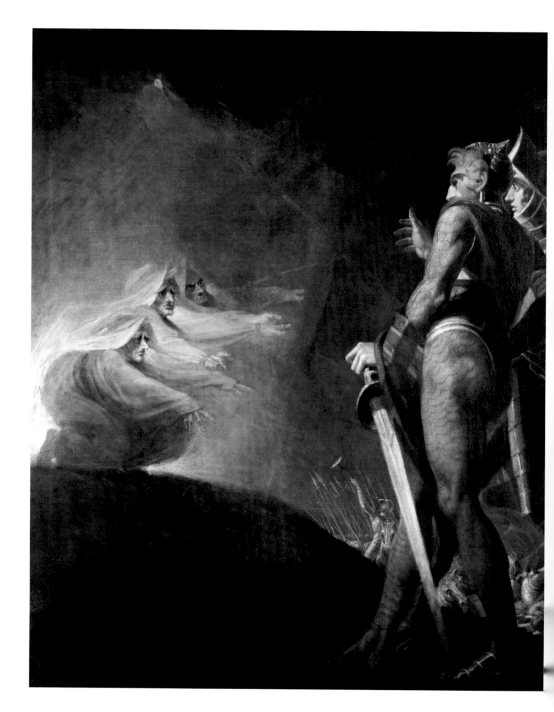

63 JOHN MARTIN (1789–1854)

Macbeth, Banquo and the Three Witches, c.1820

Oil on canvas, 50.1 × 71 cm
Scottish National Gallery, Edinburgh
Purchased with assistance of the Art Fund, 1949

Set in a rugged and mountainous land-scape, the three witches streak into the air accompanied by lightning. To the right are the gesticulating figures of Macbeth and Banquo. A huge army is assembling on the plain below commanded by tartan-kilted warriors, compressing various scenes from the play into one grand vision, typical of Martin's apocalyptic and hugely popular paintings and prints. Martin's landscapes were initially inspired by Salvator Rosa, and show a passion for sublime grandeur.

In a brief autobiographical article in the *Illustrated London News*, 17 March 1849, Martin referred to his Macbeth as 'one of my most successful landscapes', but the larger version of this painting, exhibited at the British Institution in 1820, has been lost.

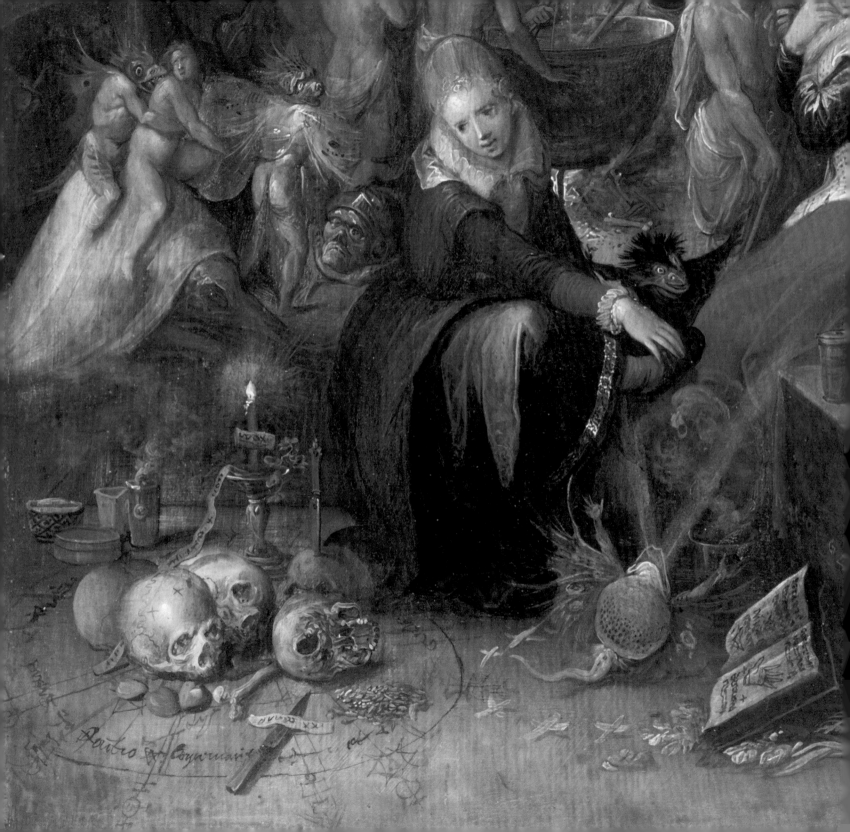

MAGIC CIRCLES, INCANTATIONS & RAISING THE DEAD

< Detail from [68]

Many paintings that are loosely titled witches' sabbaths are composite images that involve details of magic circles and the paraphernalia of black magic.

Necromancy, as established during mediaeval times, was mainly associated with male magicians, such as the twelfth-century Albertus Magus, but was gradually assumed into female witchcraft, even though women were chided for being illiterate. Magic circles were ordained spaces for demons, traced on the ground with a sword or knife. They would contain ritual objects such as a sword, rings, sceptres, skulls, mirrors, human body parts, vessels for oil and incense, and magical signs such as the tetragrammaton (a term for the unspoken name of God), and the pentagram or 'pentacle of Solomon' (a five-angled symbol). The very precise rituals of necromancy were laid out and illustrated in secret texts. Benvenuto Cellini (1500–1571), the Renaissance sculptor and goldsmith, described in his *Autobiography* (1558–66) how he participated in a number of such dramatic incantations in the Colosseum when terrifying legions of demons were conjured by a necromancer.

The Old Testament contains several prohibitions against necromancy and witchcraft. Nevertheless, King Saul summoned the Witch of Endor to raise the ghost of Samuel in order to divine the outcome of the coming battle with the Philistines (1 Samuel 28: 3–25). This was a dramatic subject for artists over the centuries, even though it raised religious issues. In a famous demonological text illustrated with bold woodcuts, the *Compendium of Magic* (1608), the Ambrosian monk Francesco Guazzo suggested: 'We must understand that such apparitions are not the ordinary rule, but occur in accordance with the special and singular permission of God.' Salvator Rosa's painting of *Saul and the Witch of Endor*, 1668 (Musée du Louvre, Paris), the image of which was circulated through prints, was particularly admired in eighteenth-century Britain, inspiring versions by Henry Fuseli, Benjamin West (1738–1820), William Blake and John Hamilton Mortimer.

Raising the dead through incantations, invoking evil spirits to predict the future, and conjuring demons with 'bell, book and candle' to create black magic, usually took place in underground tombs and dark chambers, thus reinforcing the connection between magic, death and fear.

64 AFTER DOMENICUS VAN WIJNEN, CALLED ASCANIUS (1661–AFTER 1690); ENGRAVED BY JOHANN VEIT KAUPERZ (1741–1816)

Enchantress Raising the Dead, 1769

Engraving, 58.9 × 45 cm
British Museum, London

The scene is set in a graveyard with obelisks, funerary urns and classical busts with two mourning women passing by and raucous crows. The foreshortened cadaver with its head in the foreground seems to have just been disinterred from a grave. The young sorceress with a flower headdress supporting a candle, very much in the spirit of the figure in Rosa's *Incantations*, pours a potion onto the corpse, appearing to be trying to revive it for the purposes of prophecy or magic. A semi-naked necromancer engrossed in a magical text ignores the activities of the witch, supported by alembics (womb shaped vessels used in alchemy), *grimoires*, and candles on the right and an anxiously watching spectator. Van Wijnen studied in The Hague and was known to have been in Rome during the 1680s when he was a member of the Dutch *Bentveughels* (Birds of a Feather group of artists), producing prints celebrating their initiatory ceremonies. Other witchcraft subjects have been attributed to him and his Latin nickname of Ascanius suggests that he was particularly interested in the classics. It is interesting that this very elaborate and technically sophisticated engraving was made in Vienna so many years later, suggesting that occult subjects were always considered worth re-issuing by print publishers.

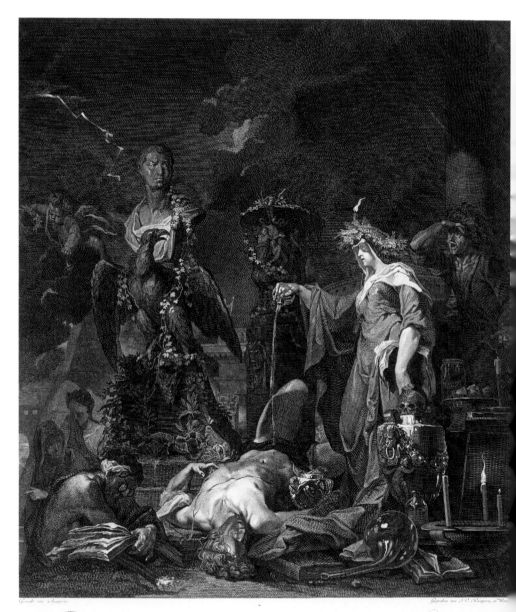

Durch umunschränkte Macht ruft Sie vom Ufer des Todes
Ihn in das Leben zurück. *Zachariä*

65 AFTER SALVATOR ROSA
(1615–1673); ETCHED BY ANDREW
LAWRENCE (1708–1747)

Saul and the Witch of Endor, 1730–54

Etching, 47.1 × 29.8 cm
British Museum, London

Rosa's enormous oil painting of *Saul and the Witch of Endor*, 1668 (Musée du Louvre, Paris) was displayed at a public exhibition in Rome organised by an elite confraternity, where it was shown alongside paintings of religious, mythical and history subjects. It shows the moment when the spirit of the prophet Samuel, hooded in a long mantle, has been summoned by the semi-naked witch lighting a flame from a branch, while Saul bows his head to Samuel his mentor. The scale of the figures is much larger than in Rosa's *Incantations*, so that they crowd the darkened space. The witch with her hair upstanding like flames mingles into the crowd of demons and familiars above her, including chimeric horrors compounded from human and animal skeletons. There were many engravings after this popular image, including this very late print in reverse by 'A. Laurentius', Andrew Lawrence a British engraver living in Paris. The monochrome print reveals far more detail than the painting, including the terrified military attendants and floating centaurs near the urn with bones and magical text. In Britain, the artist and writer Jonathan Richardson (1665–1745) praised this work as Rosa's finest: 'The expression of Horror and Witchery is Perfection'.

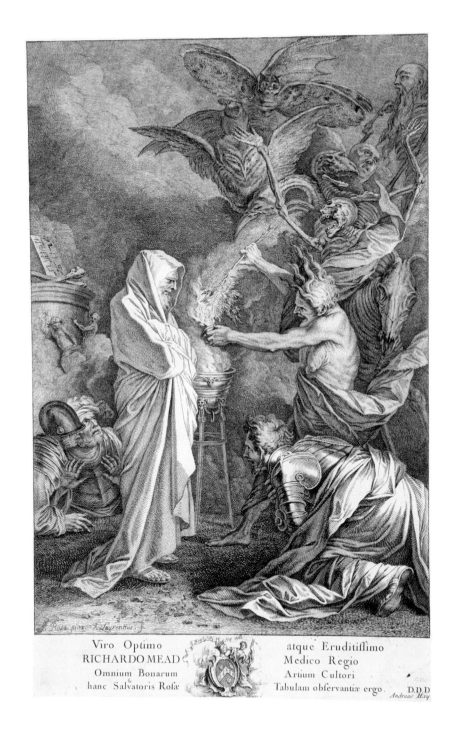

Viro Optimo atque Eruditiffimo
RICHARDO MEAD Medico Regio
Omnium Bonarum Artium Cultori
hanc Salvatoris Rofæ Tabulam obfervantiæ ergo. D.D.D
 Andreas Hay

66 AFTER JOHANN HEINRICH SCHÖNFELD (1609–c.1683); ENGRAVED BY GABRIEL EHINGER (1652–1736)

Saul and the Witch of Endor, c.1670

Etching and engraving, 42.3 × 31.4 cm
Ashmolean Museum, Oxford

The German painter and etcher Schönfeld spent time in Rome during the period before Rosa painted *Saul and the Witch of Endor* 1668, but unlike Rosa's concentration on intense drama, Schönfeld introduces flying witches in the sky beyond the cave and skeletal figures emerging from urns. A preliminary version of this work in the Staatsgalerie, Stuttgart, *c*.1670 consists of a partial print of the kneeling Saul communing with Samuel as he emerges from his grave, to which other details have been added in grey pen and ink and free washes. Engraved by his pupil Gabriel Ehinger, the final print maintains the stylistic distinction between the free quality of the background, and the careful burin work of the frontal figures. Details of the incantatory circle with snakes, skulls, frogs and magical text are copied exactly from the drawing; the quick squiggles representing flying witches have been elaborated on, from the sketchy drawing into mounted hags. The awkward proportions of the gaunt witch contrast with the more classical proportions of Saul in his Renaissance armour.

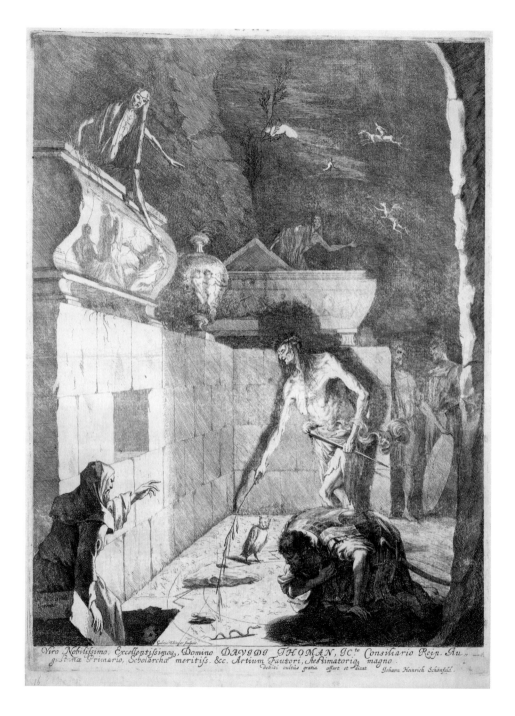

67 ATTRIBUTED TO LUIS PARET
Y ALCÁZAR (1746–1799)
Witchcraft Scene
Brown ink and brown-grey wash, with red chalk
touched with white, 33 × 27.5 cm
British Museum, London

The artist employs a limited range of
coloured ink washes to enliven this
horrific scene of an incantation within a
dark vaulted cellar, where a nude woman
at the back is lifting down a vase, while
in the front two other hags manhandle
body parts, bones, *grimoires* and a flaming
torch within a magic circle. Paret was
born in the same year as Goya, to whom
this drawing was at one time attributed.
Rather than deploying witchcraft imagery
for the purposes of social and religious
commentary, this work is obsessed with
revealing the foulness of female witches
and is more akin to images made in the
previous century. A child prodigy, Paret
entered the Academy of San Fernando in
Madrid (later the Royal Academy) at the
age of ten, and he studied in Rome and
France encompassing a wide range of
styles from the classical to the rococo. He
designed a series of costume prints and
this work is decidedly theatrical in tone.

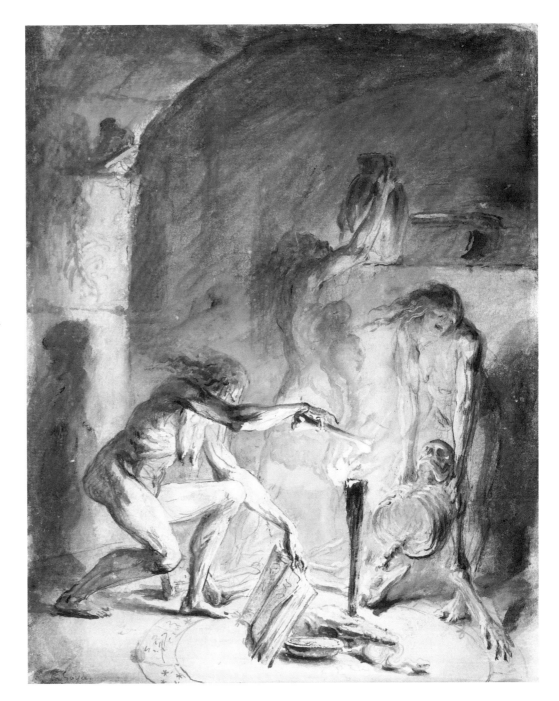

68 FRANS FRANCKEN II
(1581–1642)

Witches' Sabbath, 1606

Oil on oak panel, 63 × 50 cm
Victoria and Albert Museum, London

This painting takes us into a witches' kitchen with a coven assembled to prepare for the sabbath, while a raging fire viewed through the door is a reminder of the *maleficia* (evil deeds) that witches practise daily against the community. A nude witch is flying up the chimney on the right with its shelf of skulls, cats and a lighted 'hand of glory'. The two beautiful young witches in the foreground with their ruffs and rich clothes, concentrating on an incantation could well be courtesans: the figure in a blue dress stirring the enormous cauldron behind them wears the three-pointed paper cap of a brothel keeper. As in all the witch paintings Francken produced under the Catholic Habsburg rulers of Spain and Flanders, diabolical creatures from the imagination of Hieronymus Bosch and Pieter Bruegel the Elder mingle with the paraphernalia of necromancy. The helmeted head on the floor in the middle distance appears in later paintings of Shakespeare's Macbeth and the skulls, knife, mandrake root and candles in a magic circle are listed in the *grimoires* being read by the old hag on the right.

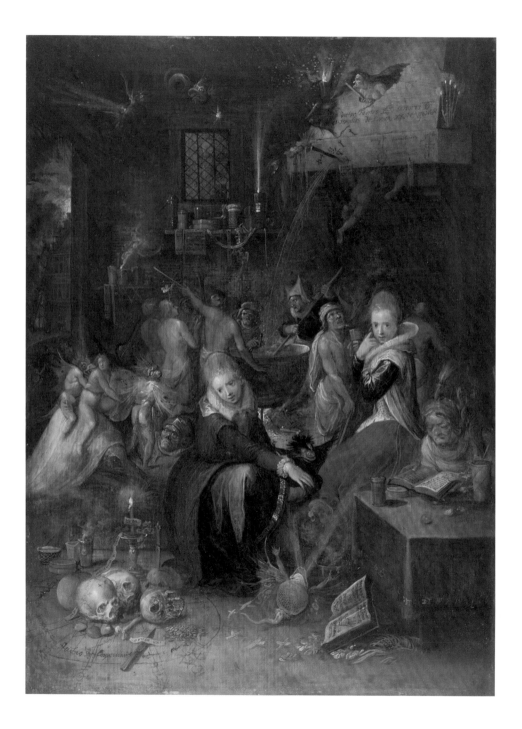

69 FRANS FRANCKEN II
(1581–1642)

Witches' Gathering

Pen and brown ink with blue-grey wash,
21.7 × 16.1 cm
British Museum, London

This extraordinarily busy drawing does
not relate to any particular painting from
the Francken workshop but piles up
groups of figures in a magical space that is
partially indoors but also an open ground
for a magical incantation. At the top of the
drawing, circular ruined buildings enfold
a magic circle in which a male magician
is conjuring spirits and serpents with his
wand, watched by a demonic crowd of
spectators and attracting owls, dragons
and flying witches. This is the reverse
image of the background scene in Merian's
1626 *Zauberey* print of Herr's image [36].
In front of the conjuration, a clothed
witch squats before a nude standing
figure with her arms up engaging in some
interesting activities with a brush. Another
small magical circle with a bearded sage
or alchemist and companion witch at a
table leads us seamlessly into the foul and
crowded witches' kitchen. One witch flies
up the large chimney on a broomstick and
another emerges at the top. On the other
side witches are busy beside a smaller
fire, reading *grimoires*, with pots and jars
of ingredients, including bones and dead
babies and an attendant skeleton. The
nude figure on the left is rubbing her body
with flying salve.

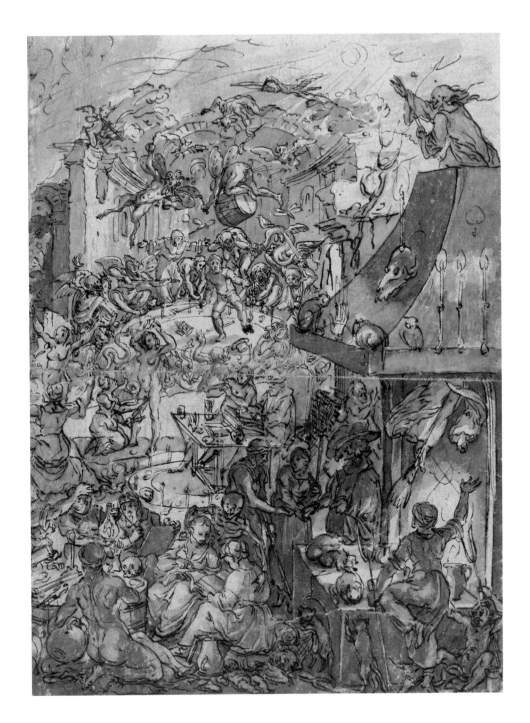

70 AFTER JOHN HAMILTON MORTIMER (1740–1779); MEZZOTINT BY JOHN DIXON (c.1740–1811)

The Incantation, 1773

Mezzotint, 60.1 × 48 cm
British Museum, London

Mortimer's painting of *The Incantation* was exhibited at the Society of Artists, London in 1770 but was subsequently lost, either through fire or deterioration. The dramatic large mezzotint after the painting was marketed by Boydell's Shakespeare Gallery. The notion of an incantation was probably influenced by Rosa's *Saul and the Witch of Endor* painting: Mortimer was known as the 'English Salvator' with good reason. However, the composition was possibly inspired by Richard Glover's play *Medea*, performed at the Drury Lane Theatre, London, between 1766 and 1767 (there is an engraving by Daniel Dodd (active 1761–died 1780) of *Mary Ann Yates as Medea*, 1777 where a scene of incantation is performed on a darkened stage in front of a cowering and horrified Medea). This dramatic composition takes place at the mouth of a cave where the hag brings forth flames within the magic circle incised on the ground by raising her right hand with its wand in a melodramatic gesture. Almost lost in the rich black, velvety mezzotint background are the bones of animals behind the smoking cauldron, and a human skeleton embraces a huge *grimoire* on a ledge to the left, almost as out of scale as the huge book of spells in Goya's theatrical painting *The Forcibly Bewitched* [42].

71 AFTER JOHN HAMILTON MORTIMER (1740–1779);
MEZZOTINT BY ROBERT DUNKARTON (1744–1811)

*Sextus, the Son of Pompey, Applying to Erichtho to Know
the Fate of the Battle of Pharsalia*, 1776

Mezzotint, 60.4 × 48 cm
British Museum, London

This print forms an interesting pair with
Mortimer's *Incantation* image; the original
painting, exhibited at the Society of Artists,
London in 1771, is lost. Nicolas Rowe's
eighteenth-century English translation of
Lucan's *Civil War* (AD 61–5) had re-awakened
an interest in the ghastly Thessalian witch
of Book VI. She was employed by Pompey's
son to reveal the outcome of the approaching
battle of Pharsalia (48 BC) in which the
General Pompey would be defeated by Julius
Caesar. Erichtho beats a mangled cadaver to
summon the evil spirits:

> With curling snakes the senseless Trunk she beats
> And curses dire, at ev'ry lash repeats;
> With magic Numbers cleaves the groaning
> Ground
> And, thus, barks downwards to the
> abyss profound.

The emaciated, grimacing and raggedy
Erichtho holds a rope (the symbolic *cordello*
of witchcraft) in her claw-like hand and turns
to look at the bunch of serpents in her other
hand. The foreshortened cadaver is partially
lost in the gloom, as is another brooding
attendant, well wrapped in a hood in the
manner that Fuseli was also to adopt. Sextus
is transfixed with horror while his soldier
guard turns away from the brutality of a scene
redolent with 'horrific sublime'.

72 JAN VAN DE VELDE II
(c.1593–1641)

Sorceress, 1626

Etching and engraving, 21.5 × 28.8 cm
Ashmolean Museum, Oxford

The dramatically highlighted sorceress inside a raised magic circle is throwing powder from a horn into her cauldron, joined by parabolas of fumes arising from the pipes of an assemblage of pipe-smoking demons and a somersaulting demon with pipes stuck in his bottom. This intense and sardonic image has a complicated genesis. Van de Velde was much influenced by the 'black manner' of Hendrik Goudt (1583–1648) who had engraved seven of the nocturnal paintings by the German artist Adam Elsheimer (1578–1610). Goudt lived in the house of the melancholy Elsheimer in Rome where they were also joined by David Teniers the Elder. They were all associates of Peter Paul Rubens (1577–1640). Rubens included witches in his great cycle of scenes from the life of Marie Medici (Musée du Louvre, Paris).

73 JOHN WILLIAM WATERHOUSE
(1849–1917)

The Magic Circle, 1886

Oil on canvas, 182.9 × 127 cm
Tate, London

The entranced witch staring into a vertical
spume of smoke does not look at her right
arm, holding a wand to incise a magic
circle that hisses with white light on the
ground; nor does she look at the bronze
boline, or sickle-shaped ritual knife, in
her other hand. Her eyes are obscured
by her low fringe of pitch-black hair, and
she wears a necklace of an ouroboros.
Flowering herbs are fixed around her
waist and helmeted Greek warriors copied
from a vase painting are embroidered
on her skirt. The only active agents in
the curiously empty picture, lacking the
usual clutter of the emblems of sorcery,
are black crows, two of which perch
dangerously on the glowing brazier. The
witch appears to be alone in a desert plain
in front of massive cliffs with primitive
dwellings above, but possibly there is an
ominous transparent creature at the back
left next to a landing crow, almost lost in
the vigorous brushwork, as well as some
squatting witches in front of a curiously
illuminated cave on the right.

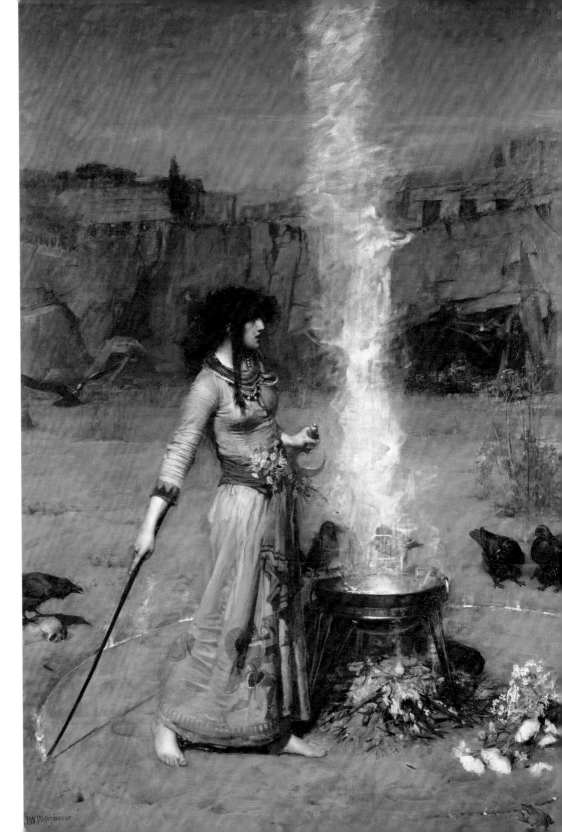

THE PERSISTENCE OF WITCHES

< Detail from [84]

Persistent images of the hideous, envious witch crone and the sinister sirens of the night were an important aspect of the Symbolist movement in the late nineteenth century, and also continued as powerful generators of art, literature, music, opera and film in the twentieth century. Embedded in the dream imagery of Surrealism and other modern movements such as Expressionism, these representations remained all the more potent because of the long history behind their genesis.

Witchcraft was appropriated for children's consumption in the late eighteenth and nineteenth centuries in increasingly sanitised formats, separating ugly history from delightful fairy tales. Tales of witches in text and illustration have never entirely lost their thrill but have become the designated space for exploration of dark and hidden desires, which the revelations of psychology have relocated within the individual unconscious. In the last decades of the twentieth century, children have become the witch practitioners in a new era of filmic and animation fantasy, integrating Gothic horror with modern technological magic.

The new 'sciences' of the nineteenth century, psychology and ethnology, were also the contexts in which the myth of the Great Mother and early matriarchal fertility cults were 'excavated' from repressed histories and misunderstood artefacts by folklorists and historians of comparative religion, such as J.G. Frazer in *The Golden Bough* (1890). Margaret Murray's book about ancient Goddess worship, *The Witch-Cult in Western Europe* (1921), not only influenced witchcraft historians but was also embraced as the basis of warm, women-dominated cults by adherents to neo-paganism and Wicca.

The rise of feminism in the twentieth century challenged centuries-old literary and visual stereotypes of women as entrenched forms of discrimination, radically affecting many women practitioners in the arts. This sometimes led to re-presenting 'abject' images of women's bodies as a deliberate if deeply disturbing form of visual criticism. Within the closely argued area of body politics of recent years, such images have taken on new meanings, inversions and subtleties and artists have increasingly turned to personal biographies for their source material. Misogyny, gender, age inequalities and, increasingly, the commodification of youth and beauty, so closely related to the dualistic stereotype of the 'witch', remain significant issues in modern society and culture.

74 PAUL DELVAUX (1897–1994)

The Call of the Night (*L'Appel de la Nuit*), 1938

Oil on canvas, 110 × 145 cm
Scottish National Gallery of Modern Art,
Edinburgh

Delvaux, a maker of surrealist dream images if not an official Surrealist, whose classically drawn nude women in mysterious townscape settings are both erotic and troubling, knew the work of his fellow Belgian, the Symbolist Félicien Rops. Rops's obsession with death, sin and pollution was expressed in prints of women as evil predators that recaptured the malignity and misogyny of earlier portrayals of witches. Delvaux produced far more benign images; nevertheless, this painting of 'women of the night' is not without ambivalent layers of symbolic meanings. The threatening aspect of the sexuality of the women is emphasised by the desolate landscape which they inhabit, with blasted trees, rocks, skulls and bones: this is the landscape of death as well as sex. Static, the hair of two of the figures has metamorphosed into ivy, which has rooted itself in the earth and prevents the figures from escaping: they are held, motionless, as objects of our gaze. The surreal ivy combines the traditional images of woman as a 'clinging vine' and the wild tresses of the witch whose hair binds, poisons and entraps men, celebrated in innumerable, literary works and paintings of the nineteenth century.

75 EDWARD BURRA (1905–1976)

Dancing Skeletons, 1934

Gouache and ink on paper, 78.7 × 55.9 cm
Tate, London

There was an increase in grotesque subject matter in Burra's work after his visits to Spain in the 1930s. This image seems to have been borrowed from Mexican Day of the Dead imagery and Surrealism, although the four brightly coloured dancing skeletons in hats probably owe more to the long European tradition of the *danse macabre*. It has been suggested that the theme of decay extends to the surrounding landscape including the crumbling red brick wall with incisions into the dry gouache. Three cadavers dangle from a gallows on the ruined buildings on the left. There is evidence that Burra appropriated this ghoulish subject from a photograph of hanged African rebels in the Belgian magazine *Variétés*, to which he shared a subscription with his fellow British artist Paul Nash (1889–1946). The moon, lighting up the sea beyond, is a symbol of permeating evil.

76 EDWARD BURRA (1905–1976)

Scarecrows, 1949
Gouache and ink on paper, 79 × 56 cm
Kirklees Collection, Huddersfield Art Gallery

A spiral of figures including an owl and nude witches tumble out of the sky in a gloomy landscape. A bird-masked figure confronts the raggedy straw-stuffed scarecrow attended by a hooded female figure. One of Burra's most disturbing late paintings is *The Straw Man*, 1963 (Pallant House Gallery, Chichester), which chillingly depicts a group of urban men ruthlessly kicking and abusing a figure filled with straw. Burra was a graphic artist who also designed for the theatre and the ballet. In 1948 he even designed a film set staging the Faust legend in post-war Britain. For most of his career he produced large-scale paintings in gouache on joined sheets of paper, experimenting with the expressive means of this neglected medium. He mainly concentrated on landscapes in his later years, including bleak Northumberland vistas, and scenes from Yorkshire and Dartmoor. These pictures of encroaching despoliation include roads and sometimes cars and trucks. For George Melly, the Surrealist and jazz musician, they evoked lines from W.H. Auden:

> *When the green field comes off like a lid*
> *Revealing what was much better hid —*
> *Unpleasant.*
> (from *The Two or The Witnesses*, 1932)

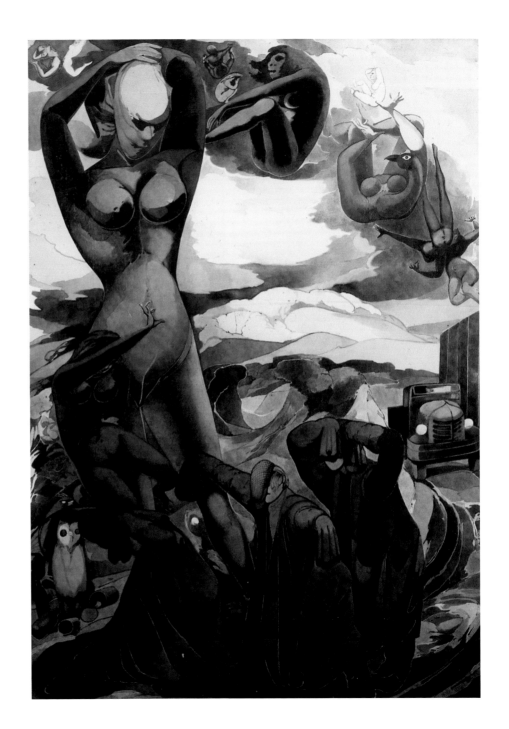

77 JOHN BELLANY (B.1942)

The Witch, 1968

Oil on board, 91 × 91 cm
Royal College of Art, London

Bellany painted this unsettling image of a witch while a postgraduate student at the Royal College of Art in London. For Keith Hartley, who curated the Scottish National Galleries' exhibition on the artist (2012), 'It reflects Bellany's strong interest in the Northern European tradition of painting and printmaking at the time, which tended to extend for John at least to Goya as well'. Featuring an old hag with her familiar, a cat, at night under a crescent moon, this painting has much in common with earlier representations of witches. Yet it is also unmistakably a Bellany from the late 1960s, one of the most creative periods in his career; thanks to the fish (most probably symbolising Christianity), the witch's frontal pose, and her placing behind the strange, high surface in the foreground. Although Bellany's picture has a similar format to Sandys's glamorous classical images of Medea [15] and Vivien [16], she looks more like one of the old fish-gutters he depicted at this time, standing behind her work counter after hours. PA

78 ALAN DAVIE (B.1920)

*Woman Bewitched by the Moon No.2
(Opus O.175)*, 1956

Oil on masonite, 152.8 × 122 cm
Scottish National Gallery of Modern Art,
Edinburgh

The Scottish artist Davie was introduced to
American Abstract Expressionism at the
Venice Biennale in 1948, but his rooting in
figurative art – in making images – would
never desert him. The paint in this work is
wild and laid on thickly with lines drawn
into the paint at speed. What emerges is
a group of swirling figures, some animal,
some huge-headed demons, which probably
suggested the title to the artist well after
the work was completed. The tense act of
making and the inventive processes, out
of which shapes or recognisable figures
emerge as an 'automatic' process without
the interference of a critical conscious-
ness, were more important to Davie than
preplanned subjects. Later in his travels he
observed the craft and symbols of peoples
engaged with traditional magic or rituals,
from Indian villages to Native American
pottery, Venezuelan rock paintings to
Australian Aboriginal art, which lead to
much tighter assemblages of symbols. This
is the style of a group of works associated
with magicians in the 1980s, which arose
from his mural for the Tarot Garden of
the French artist Niki de Saint Phalle
(1930–2002), for which he was asked to
paint the interior of the head of *Il Mago* (The
Magician), a symbolic image of tarot cards.

79 JOHN CIMON WARBURG
(1867–1931)

The Incantation, 1901

Platinum print photograph, 16 × 20 cm
National Media Museum, Bradford

John Cimon Warburg took up photography
in the late 1880s, becoming a member of the
Royal Photographic Society in 1897 and a
Fellow in 1916. He was primarily a pioneer
in colour photography (he developed the
Autochrome Lumière process) and created
quiet, poetic views of English villages and
landscapes. This atmospheric evocation of
an incantation refers to the craze for séances,
table-turning and the paranormal that con-
tinued to fascinate middle-class Britain well
into the twentieth century. As well as crystal
balls, such photographs depicted ghosts and
fairies, such as the famous Cottingley fairy
photographs of Elsie Wright and Frances
Griffith, which the spiritualist Sir Arthur
Conan Doyle so disastrously defended in
1920. Warburg's isolated sorceress standing
in front of a vertical spume of smoke is very
close to John William Waterhouse's *Magic
Circle*, 1886 [73] but is lost in a sparkling
overlay of blurred lights and ghostly double
images. Warburg created an earlier view of
the same figure, cloaked and draped with
rich fabrics over a long white tunic, entitled
Woman with a Vase, 1908. In this photograph,
without subsequent surface manipulations,
the smoke from the vase arises in an irregular
plume and the manufactured magical
atmosphere is lost.

80 CLARENCE HUDSON WHITE
(1871–1925)

The Watcher, 1906

Platinum print photograph, 22 × 16 cm with mount
National Media Museum, Bradford

This romantic image was created by the American photographer Clarence Hudson White during a regular holiday in Maine. Maine was the location of two other of his well-known images, *The Pipes of Pan* and *Spring (Morning)* of 1905. The static female figure in her long 'Eastern' robes is not looking into her crystal ball, as is common in other photographs of the time heavily influenced by Symbolist painting, but rather she is carefully posed – like the slender young birch trees – in front of a rising sun. She projects the moodiness and mystery sought after by the English Brotherhood of the Linked Ring, founded in 1892, of which White was elected an overseas member, along with fellow photographer Alfred Stieglitz (1864–1946). The Linked Ring aimed to promote photography as an equivalent of painting and sculpture. Works were shown at the London Photographic Salon, the annual exhibition for 'pictorial photography in which there is distinct evidence of personal feeling and execution'. Following this event, and that of the 'Secessionist photographers' of Munich who had exhibited their work alongside prints by Edvard Munch (1863–1944) and Henri Toulouse-Lautrec (1864–1901) in 1898, Stieglitz established The Photo-Secession in 1902 in New York. White, who founded a school of photography, collaborated with Stieglitz on experiments aimed at extending the pictorial and technical possibilities of photography.

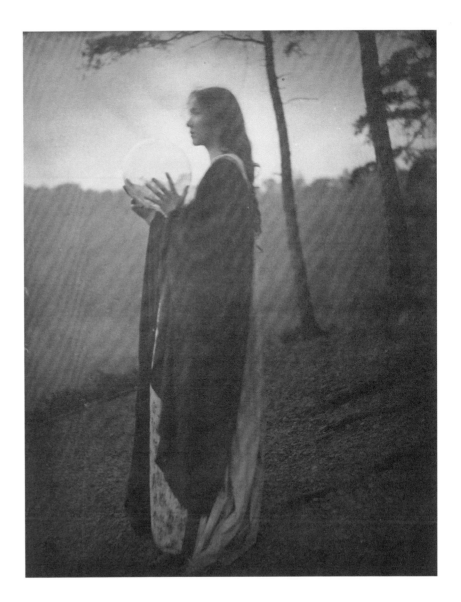

81 CLARKINGTON & CO.

Johnny Clarke as a Witch, late 19th century

Photograph, 8.7 × 6.1 cm
Victoria and Albert Museum, London

This sepia photograph depicts the actor John Clarke (1828–1879) dressed as a witch against the backdrop of a stage production that cannot be identified. The details of the ridiculous cap and gown suggest that it was a farce. A satchel hanging on the wall is probably one in which herbs, objects and living specimens would be collected for magic spells. In the mid-nineteenth century most actors and actresses had studio photographs taken of themselves in theatrical roles to be distributed as '*cartes de visite*' or 'cabinet cards'. These were albumen prints made from glass negatives, attached to a card bearing the photographer's name. The process was developed in France in 1854 by Parisian photographer André Disdéri and popularised by Napoleon III. Their popularity spread worldwide in the 1860s and the public exchanged and collected such images in albums as they did cigarette cards. Small format *carte de visite* photographs of the actor Clarke show him in various guises, often frozen in a dramatic posture with another actor in well-known stage productions or as part of opening-night cast records.

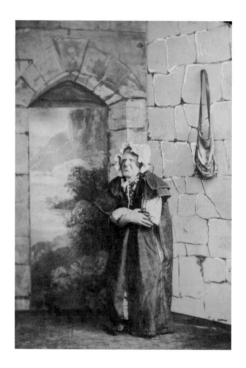

82 KIKI SMITH (B.1954)

from *Out of the Woods*, 2002
Untitled (*Encryption*) 1:5
Photogravure on paper, 50 × 40 cm
Tate, London

The five prints in this series depict Smith dressed as a witch in a black cape, long skirt and heavy boots, posed against a black background. The images have been digitally modified so that her head is enlarged and her claw-like hands are reduced in size. The text under each image relates to the five senses: this image reads 'On still moonlight a witch alone haunts the dark. She's been touched.' The prints relate to a silent film, *The Wind*, 1928, starring American actress Lilian Gish. Smith, a feminist sculptor, formidable draughtsperson and printmaker, has long been interested in the subject of the witch. In 2000 she portrayed herself as such in a series of colour photographs with black apples, a commentary on Eve and the apples of sexual shame. She has memorably said: 'I have always thought of myself as a crone.' Her sculptures, originally in papier maché, deal with those visceral issues described as 'abject': that is, mangled bodies leaking blood, vomit or body fluids, or covered in hair. Her upside-down bronze sculpture *Lilith*, 1994, suspended from the wall by hooks in a totally disempowered position, is a commentary on male attitudes to the female body.

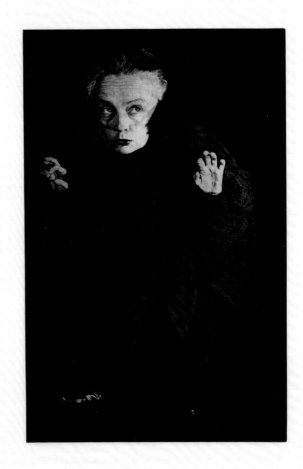

*On still moonlight a witch alone haunts the dark.
She's been touched.*

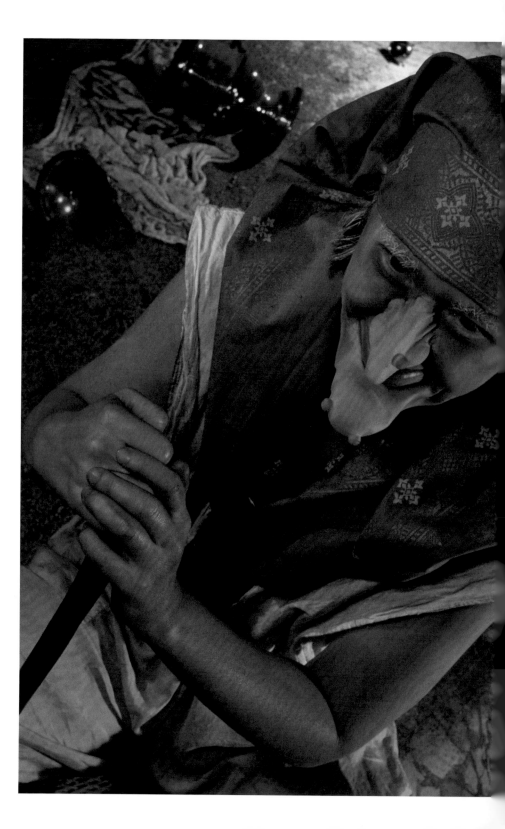

83 CINDY SHERMAN (B.1954)

Untitled No.151, from the *Fairy Tales*
series, 1985

Colour photograph, 180.3 × 120.7 cm
Sprüth Magers Gallery, Berlin/London

Cindy Sherman has preferred never to title
her photographs or the series to which they
relate; however, the anxiety-inducing images
from the series referred to by others as *Fairy
Tales*, 1985, and *Disasters*, 1986–9, depict
monsters or witches, bodies emerging from
the earth or decomposed body parts within
disgusting environments of vomit and slime.
Typically, in this eerily bright photograph,
Sherman's own face has been transformed
by a prosthetic nose and huge chin covered
with warts, and she holds up a flaming wand,
where the flame is undoubtedly a crude sub-
stitution in fabric. The mixture of detritus and
mysterious coloured lights in the background,
and the waxwork-like arms, increase the
uncanniness of this image. By representing
herself in photographs enacting poses from
films or reconstitutions of historic paintings,
or employing prosthetic parts to make up
female bodies that appear to have been pulled
apart and recomposed, Cindy Sherman has
challenged the veracity of photography. For
her, photography is not an accurate recording
of the 'actual' world but a transformative and
fictional medium as powerfully metaphorical
as painting or drawing. Furthermore, her
photographs subvert the last remnants of
notions about the idealised female body in a
postmodern world.

84 ANA MARIA PACHECO (B.1943)

In Illo Tempore IV, 1994

Oil on gesso, 260 × 183.4 cm
Pratt Contemporary, Sevenoaks, Kent

In Illo Tempore (In That Time) is the title
of a series of mysterious paintings in
which Brazilian-born Pacheco explores
the disturbing world of fairies and
witches, some of it based on readings of
her own family relationships as a child.
The flaming torch in this dark painting,
suspended on a slender, bending wand,
recalls the torch of Venus that is so often
brandished by witches in sixteenth- and
seventeenth-century representations. The
reprehensible sexuality of witches that was
at the core of these historical images is just
suggested here by the figure on a circus
plinth wearing a bathing costume, whose
pale face is lit up by the flame that will soon
destroy the paper bag. The ram's head,
more often associated with the Devil, is
here worn by an older figure in an ocelot
coat who has turned her back on the female
victim, and is about to be rolled off stage
on the wheeled cart of which she holds
the string. Humiliated women exposed to
public view on stages or display carts were
the subject of a series of prints made at the
time by Pacheco.

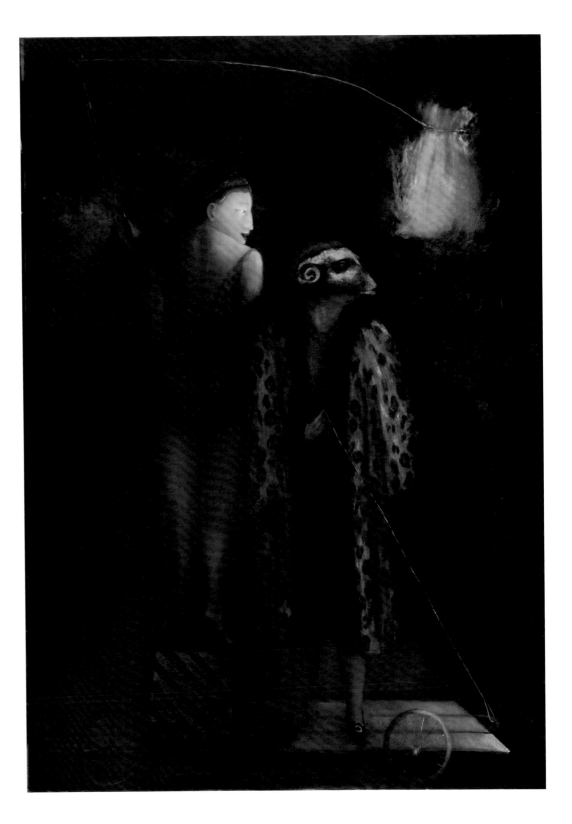

85 MARKÉTA LUSKAČOVÁ (B.1944)

Woman in a Cat Mask, 2000, from the series *On Death and Horses and Other People*, 1999–ongoing
Gelatine silver bromide photograph, 50 x 40 cm
Courtesy of the Artist

Czech-born photographer Luskačová, who has lived and taught in Britain for many years, trained as a sociologist and her intense photographs reveal the impassioned eye of a social commentator. She began to photograph Czech Carnival festivities in 1999, making pilgrimages to Bohemian cities, towns and villages. This dark and mysterious image of a cloaked figure wearing a garlanded feline mask, appearing to be carrying a wand and holding an indefinable bird-mask to its stomach, is typical of the macabre and ingenious costumes of the participants. She is taking part in the annual procession that leaves the small town of Roztoky and makes its way through the bleak, wintry and snow-bound countryside uphill to a neighbouring village. It is difficult to pinpoint the exact meaning of this slightly demonic garb, but like the other costumes of the Carnival masquerade, including figures on stilts or with bird, death's-head or horse masks, or wearing pointed witch hats, the imagery conjured in this ritual accesses the macabre and the occult. The fact that the costumes are made by hand out of simple materials and the mummers do not resort to mass-produced plastic masks, adds a particular poignancy to this celebration of ritualised anarchy in a religious calendar.

86 PAULA REGO (B.1935)

Straw Burning, from the *Pendle Witches* series, 1996

Etching and aquatint on paper, 45.2 × 29.7 cm
Tate, London

Pendle Witches was a series of etchings inspired by the poems of Yorkshire-born Blake Morrison, which were also published as an illustrated book in 1996. As is usual with Rego's response to literary texts, she comes to subjects in her own unexpected, tangential manner, exposing the dark, hidden aspects that inflect her drawings, pastels and paintings. The title poem of the series sets the scene of male adolescent sexual fears of older women. Rego has interpreted the subject of straw burning, 'our summer's cremation / the last of August', as a sexualised image, with a confused, slightly old-fashioned bridal figure in front of dark flames, caught up in a confusion of witchcraft symbols, mice, insects, serpents, bird demons and a devilish goat's head. The text refers to 'the flames / rushing towards us / like a lynch mob'. Morrison has also published a book of poems, *A Discoverie of Witches* (2012), based on the Pendle witch trial (1612) in Lancashire when ten people were hanged. His poem *Old Witches* is a fitting tribute to the hags in this catalogue who were once 'hanged or drowned':

> *The more blind, deaf, lame, arthritic,*
> *hairy-chinned, bowbacked and incontinent,*
> *the greater the power they have.*

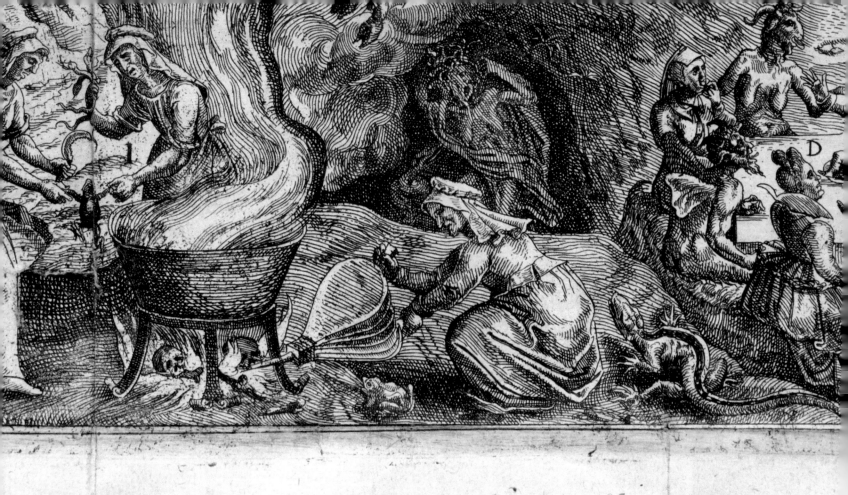

qui preſche auec cinq cornes,
andelles & feux du Sabbat.

ins fauorie à ſeneſtre.

reſente vn enfant qu'elle a ſe-

n Demon pres d'elle : Et en ce

e pendus, cœurs d'enfans non

rs du commerce & vſage des

luſieurs poures Sorcieres re-

ndes ceremonies.

eus de viandes ou fugitiues

H Au deſſous ſe void vne troupe de femmes & fil
 dehors le rond de la danſe.

I Voila la Chaudiere ſur le feu pour faire toute ſort
 rir & maleficier les hommes, ſoit pour gaſter le beſ
 paux en main, & l'autre leur couppe la teſte, & le
 chaudiere.

K Pendant cet entretien pluſieurs Sorcieres arriuen
 lais, d'autres ſur des Boucs accompagnees des enfa
 leſquels elles viennent offrir à Satan: D'autres part
 l'air, s'en vont ſur la mer ou ailleurs exciter des ora

L Ce ſont les grands Seigneurs & Dames, & autre
 ètent les grands affaires du Sab

HISTORICAL PRINTED TEXTS
IN THE EXHIBITION

< Detail from [35]

MOLITOR c.1489

Ulrich Molitor, *De lamiis et phitonicis mulieribus*, Johann Otmar, Reutilingen, not before 10 January 1489 [University of Glasgow Library: Sp Coll Ferguson An-y.34]

SPRENGER AND INSTITORIS 1494

Jakob Sprenger and Heinrich Institoris, *Malleus Maleficarum*, Anton Koberger, Nuremberg, 1494 [University of Glasgow Library: Sp Coll Ferguson An-y.12]

SCOT 1584

Reginald Scot, *Discouerie of Witchcraft: vvherein the lewde dealing of witches and witchmongers is notablie detected*, William Brome, London, 1584 [University of Glasgow Library: Sp Coll Ferguson Ah-b.32]

LONDON c.1592

Newes from Scotland. Declaring the damnable life of Doctor Fian a notable sorcerer, who was burned at Edenbrough in Ianuarie last, T. Scarlet for William Wright, London, 1592? [University of Glasgow Library: Sp Coll Ferguson Al-a.36]

JAMES VI 1597

James VI, King of Scotland, *Daemonologie: in forme of a dialogue, diuided into three books*, Robert Waldegraue, printer to the King's Majestie, Edinburgh, 1597 [National Library of Scotland, Edinburgh: L.C.1499]

GUAZZO 1608

Francesco Maria Guazzo, *Compendium Maleficarum*, Milan, 1608 [University of Glasgow Library: Sp Coll Ferguson Ag-c.50]

DE LANCRE 1613

Pierre de Lancre, *Tableau de l'inconstance des mauvais anges et demons*, second edition, Nicolas Buon, Paris, 1613 [University of Glasgow Library: Sp Coll Ferguson Al-x.50]

RIPA 1630

Cesare Ripa, *Della più che novissima iconologia di Cesara Ripa Perugino…*, Donato Pasquardi, Padua, 1630 [University of Glasgow Library: Sp Coll S.M. 1449]

HOPKINS 1647

Matthew Hopkins, *The Discovery of Witches*, London, 1647 [University of Glasgow Library: Sp Coll Ferguson Ag-d.47]

BORDELON 1710

Laurent Bordelon, *L'histoire des imaginations extravagantes de monsieur Oufle*, 2 vols in 1, Amsterdam, 1710 [University of Glasgow Library: Sp Coll Ferguson Ai-f.6]

BURNS 1855

Robert Burns, *Tam o' Shanter*, illustrated by John Faed, engraved by Lumb Stocks, James Stephenson and William Miller, Royal Association for the Promotion of Fine Arts in Scotland, Edinburgh, 1855

LONDON

(The) Lancashire witches containing their manner of becoming such; their enchantments, spells, revels, merry pranks, London [University of Glasgow Library: Sp Coll Ferguson Af-g.20]

FURTHER READING

BOSTON 1989
Alfonso E. Pérez Sánchez and Eleanor A. Sayre, *Goya and the Spirit of Enlightenment*, exh. cat., Museum of Fine Arts, Boston, 1989

CLARK 1997
Stuart Clark, *Thinking with Demons: The Idea of Witchcraft in Early Modern Europe*, Oxford, 1997

DAVIDSON 1987
Jane P. Davidson, *The Witch in Northern European Art*, Freren, 1987

FRANKFURT AM MAIN 2007
Bodo Brinkmann, *Witches' Lust and the Fall of Man: The Strange Fantasies of Hans Baldung Grien*, exh. cat., Städel Museum, Frankfurt am Main, 2007

HEINEMANN 2000
Evelyn Heinemann, *Witches: A Psychoanalytic Exploration of the Killing of Women*, trans. Donald Kiraly, London and New York, 2000

HULTS 2005
Linda C. Hults, *The Witch as Muse: Art, Gender and Power in Early Modern Europe*, Philadelphia, 2005

KORS AND PETERS 2001
Alan Charles Kors and Edward Peters (eds), *Witchcraft in Europe 400–1700: A Documentary History*, second edition, Philadelphia, 2001

LARNER 1981
Christina Larner, *Enemies of God: The Witch-Hunt in Scotland*, London, 1981

LONDON 2006
Martin Myrone (ed.), *Gothic Nightmares: Fuseli, Blake and the Romantic Imagination*, exh. cat., Tate, London, 2006

LONDON AND FORT WORTH 2010
Helen Langdon, with Xavier F. Salomon and Caterina Volpi, *Salvator Rosa*, exh. cat., Dulwich Picture Gallery, London and Kimbell Art Museum, Fort Worth, Texas, 2010

PURKISS 1996
Diane Purkiss, *The Witch in History: Early Modern and Twentieth-Century Representations*, London and New York, 1996

ROPER 2004
Lyndal Roper, *Witch Craze: Terror and Fantasy in Baroque Germany*, New Haven and London, 2004

ROPER 2012
Lyndal Roper, *The Witch in the Western Imagination*, Charlottesville, Virginia, 2012

STEPHENS 2002
Walter Stephens, *Demon Lovers: Witchcraft, Sex, and the Crisis of Belief*, Chicago, 2002

SWAN 2005
Claudia Swan, *Art, Science and Witchcraft in Early Modern Holland: Jacques de Gheyn II (1565–1629)*, Cambridge, 2005

ZIKA 2003
Charles Zika, *Exorcising our Demons: Magic, Witchcraft and Visual Culture in Early Modern Europe*, Leiden and Boston, 2003

ZIKA 2007
Charles Zika, *The Appearance of Witchcraft: Print and Visual Culture in Sixteenth-century Europe*, London and New York, 2007